IMAGES
of America

HISTORIC
RALEIGH

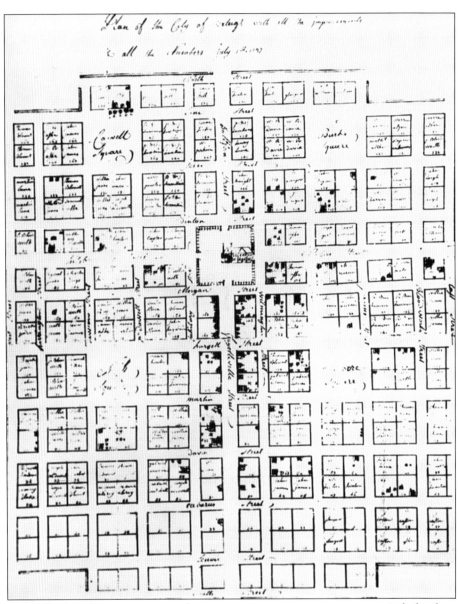

North Carolina's early years saw several existing cities serve as temporary capitals for the state. In 1788, a state commission was created to determine a permanent seat for state government. Rather than choosing an existing community, the commissioners decided that a new city located in the center of the state would be established for the capital. On March 30, 1792, the commissioners purchased 1,000 acres of land from Wake County property owner Joel Lane. Almost immediately, 400 acres of the original 1,000 were dedicated as the city center and a street grid, seen here, was designed by William Christmas. The city remained nameless until November 1792 when the state commissioners finally christened it "Raleigh," honoring Sir Walter Raleigh, the 16th-century Englishman often referred to as the father of English America. Although he never visited what is now known as North Carolina, Sir Walter Raleigh was successful in sending the first English colonists to our state and to other parts of the New World. (Courtesy Office of Archives and History, Raleigh.)

IMAGES of America
HISTORIC RALEIGH

Jennifer A. Kulikowski and Kenneth E. Peters

Copyright © 2002 by Jennifer A. Kulikowski and Kenneth E. Peters
ISBN 978-0-7385-1440-6

Published by Arcadia Publishing
Charleston SC, Chicago IL, Portsmouth NH, San Francisco CA

Printed in the United States of America

Library of Congress Catalog Card Number: 2002103786

For all general information contact Arcadia Publishing at:
Telephone 843-853-2070
Fax 843-853-0044
E-mail sales@arcadiapublishing.com
For customer service and orders:
Toll-Free 1-888-313-2665

Visit us on the Internet at www.arcadiapublishing.com

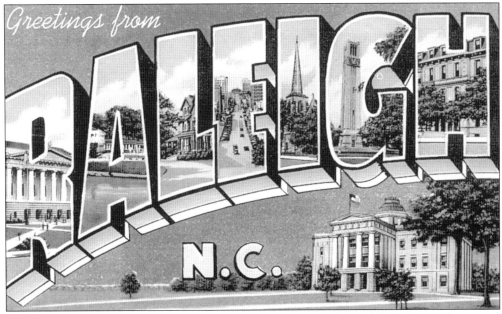

This postcard, published by Curt Teich and Co., Inc. during the middle of the 20th century, uses a large-letter format to illustrate some of Raleigh's landmarks. From left to right inside the letters are Memorial Auditorium, Pullen Park, the Governor's Mansion, Fayetteville Street, Christ Church, the NC State Belltower, and the Century Post Office. The statehouse is shown separately in the lower right corner. (Courtesy Raleigh City Museum.)

CONTENTS

Acknowledgments 6

Introduction 7

1. It Started with One Thousand Acres 9

2. From War to Prosperity 25

3. The Heyday of Downtown 41

4. Town and Gown 73

5. National Events and the Local Experience 89

6. Celebrating a Capital City 101

Index 126

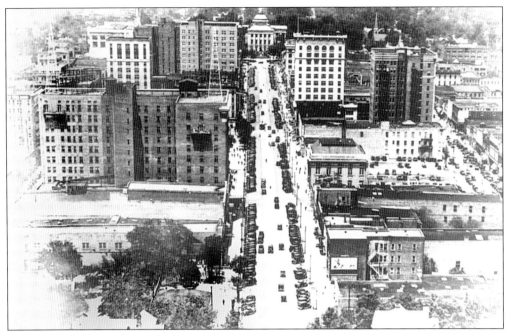

By the turn of the century, Raleigh's Fayetteville Street, shown here in the 1930s, was known as "North Carolina's Main Street" and played host to retail commerce as well as civic events. Parades to celebrate Independence Day, Christmas, returning war veterans, or the visiting circus were frequent happenings along its length. As time progressed, the street changed from mud and sand to cobblestones and finally to asphalt. The first telephone poles were erected along Fayetteville Street in 1879 and the first electric wires were strung in 1884–1885. In the 1870s, the tallest structure along it was the four-story Briggs Hardware Building and by the 1910s, it had become the ten-story Citizens National Bank building. (Courtesy Office of Archives and History, Raleigh.)

ACKNOWLEDGMENTS

The vast majority of material for this publication originated from the Raleigh City Museum. The authors consulted the museum's archives of documents related to its past and its current exhibits to produce the historical narratives contained within the book. They also relied upon the museum's collection of artifacts, photographs, and postcards to assemble the illustrations shown here.

The authors are indebted to their fellow Raleigh City Museum staff members, without whom this publication would not be possible. Special thanks to Dusty Wescott, the museum's curator, and educators Katie Dougherty and Sharon Baggett. We are grateful to the wealth of knowledge shared by local historians Elizabeth Reid Murray and Margie Haywood. Thanks also to Amber Neal, Barbara Pollard, Rebecca Hargis, Paul Harris, and all of the interns, volunteers, museum donors, and members of the Board of Directors who have contributed to the growth and success of the museum.

Finally, the authors wish to thank their families, whose love, understanding, and support was the foundation for this project.

Introduction

Created as a planned city in 1792, the area we now know as Raleigh, North Carolina had a handful of sparse settlements as early as the 1760s. Enterprising landholders like Isaac Hunter and Joel Lane owned large tracts of farmland and operated taverns and ordinaries near their homes to accommodate travelers along the main north-south route through central North Carolina. Called Wake Crossroads, this primitive outpost provided a foundation for Raleigh's future development.

By the late 1780s, North Carolina's general assembly recognized a need for a permanent location to conduct state government. Before this time, the state's seat of government had been hosted by several existing cities. Rather than select one of these communities, the legislature decided to build a new city that was more centrally located within the state. Eight commissioners were appointed to choose the new capital's location. On March 30, 1792, the commissioners purchased 1,000 acres from Wake County landowner Joel Lane and a city plan was quickly developed.

The city of Raleigh grew slowly, with state government initially its primary focus. The opening of the original statehouse in 1794 provided not only a physical location for governmental business but also a center for the community's social life. Over time, inns, taverns, dry-goods stores, coffin houses, and brickyards were established to support the burgeoning capital city. Until the Civil War, these businesses catered mostly to retail customers, providing both services and basic needs. Fayetteville Street quickly became Raleigh's commercial core as storefronts began to replace residences along the blocks south of the State Capitol. In addition to downtown commerce, a handful of mills and new ventures, like the Raleigh and Gaston Railroad, completed the composition of early Raleigh.

Raleigh emerged from the Civil War unscathed physically and a new era unfolded. Although there was an effort to establish a manufacturing base in Raleigh with cotton mills and other industries, Raleigh did not develop into a manufacturing mecca. Retail, however, flourished and a plethora of family-owned businesses dominated the downtown district. In the 19th century, Raleigh witnessed a wave of publishing enterprises as newspapers, printers, and bookbinders became part of an important means of communication and advertising. As the century progressed and the industrial revolution brought new technology to Raleigh, innovations like the Raleigh Street Railway, the Raleigh Waterworks, and electric lights on Fayetteville Street fundamentally altered the city's way of life.

In the early 20th century, Raleigh evolved to become the retail center for eastern North Carolina. People flocked to Fayetteville Street not just for shopping but also for entertainment and civic celebrations. From grand opera to vaudeville and motion pictures, Raleigh's theaters and public performance venues offered something for everyone. At the same time, East Hargett Street thrived as the African-American retail and social hub of Raleigh. Sports on all levels became a popular pastime as crowds gathered for minor-league baseball at Devereux Meadow and college football at Riddick Stadium. By World War II, automobiles and buses had replaced streetcars and buggies and Fayetteville Street reached its zenith as the "heyday of downtown" reigned.

While Raleigh's citizens trekked downtown to work and play, they returned home to residential neighborhoods. Raleigh's first neighborhoods were contained within the original

city plan but as the population grew, other residential districts were formed, often outside the existing city limits. An important component of any neighborhood was its local school, whether it was Miss Busbee's small private kindergarten or a large city high school like Hugh Morson. Some neighborhoods were influenced when six institutions of higher learning were established in Raleigh. From the earliest women's colleges to traditionally African-American institutions and, eventually, a large state university, education has played an important role in the life cycle of the city.

Like all communities, Raleigh has been touched by national events. Sometimes the local impact was felt in unique ways. For example, a connection to the USS *Raleigh* during the Spanish-American War hastened the creation of Raleigh's city flag. During the world wars, Raleigh not only lost young men to the fighting but local citizens were asked to make contributions on the home front, from buying war bonds to volunteering for the Red Cross. After World War II, the nation experienced a boom in housing. This new suburban experience was introduced in Raleigh when Cameron Village, the Southeast's first shopping center, opened in 1949. However, no other national event affected Raleigh more profoundly than the Civil Rights Movement of the 1950s and 1960s. After years of Jim Crow rule in the South, local students and activists—through marches, lunch counter sit-ins, and public protests—helped give rise to fundamental social change as new laws were enacted to protect the rights of all citizens.

Throughout its history, Raleigh has also been home to many of North Carolina's major events and celebrations. The annual State Fair brings thousands of "Tarheels" to Raleigh each year, and gubernatorial inaugurations, holidays, and other observances all give local citizens a reason to revel. As Raleigh progresses through its third century, it is a hybrid of state government and hi-tech industries, historic neighborhoods and new developments, and long-term residents and new arrivals. When viewed as a whole, all of these important elements make up the city we call Raleigh, North Carolina.

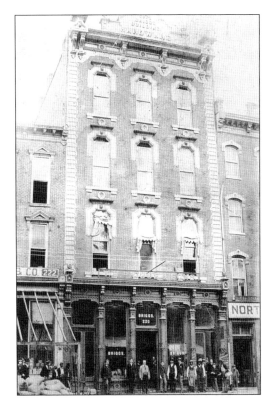

Completed in 1874, the historic Briggs Building is located in downtown Raleigh at 220 Fayetteville Street Mall. Once reputed to be the tallest structure in eastern North Carolina, it was home to a family-owned hardware store for more than 120 years. Renovated in 1997–1998, it now houses the Raleigh City Museum and other non-profit organizations. It is seen here *c*. 1890. (Courtesy Office of Archives and History, Raleigh.)

One
IT STARTED WITH ONE THOUSAND ACRES

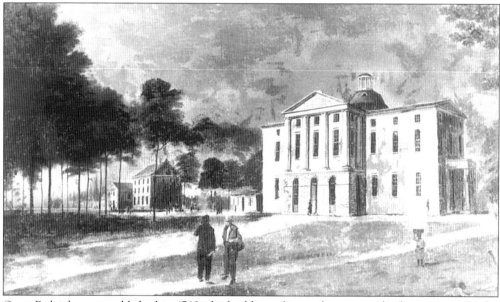

Once Raleigh was established in 1792, the building of a statehouse was the first priority for the new capital city. Hosting its first meeting in 1793, the new statehouse quickly became a center of community life. It also held lectures, concerts, commencement exercises, and theatrical performances, including the occasional acrobatic and high wire act. The statehouse was annually the scene of festive balls and held weekly religious services until the first church was built in Raleigh in the early 19th century. In 1831, fire swept the downtown area and Raleigh residents watched helplessly as the statehouse burned to the ground. The destruction of the building helped spawn a debate about the future of Raleigh as the North Carolina capital. However, the completion of a new statehouse in 1840 ended any serious questions about moving the capital. This 19th-century watercolor painting by Jacob Marling shows the east facade of the original statehouse after its remodeling in the 1820s. (Courtesy Office of Archives and History, Raleigh.)

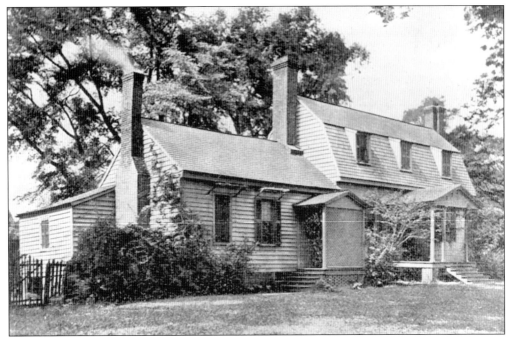

Built in the 1760s, the Joel Lane House, also known as "Wakefield," is the oldest home still standing in Raleigh, although it has been moved from its original location. It was here in 1792 that a special commission chose to purchase 1,000 acres from Lane to establish a new seat of government for North Carolina. (Courtesy Office of Archives and History, Raleigh.)

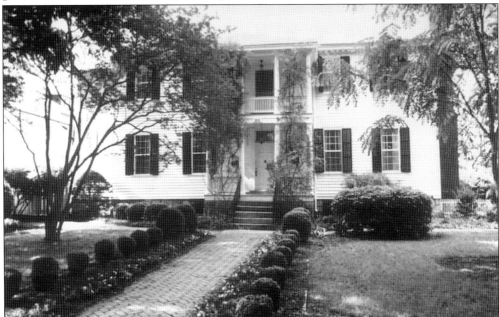

Haywood Hall is the only house built before 1800 within Raleigh's original city limits that remains on its original foundation. John Haywood, Raleigh's first mayor, constructed it in 1799. Designed in the federal style, the home's grounds include a garden. It now operates as a house museum. (Courtesy Haywood Hall.)

John Haywood was the owner of Haywood Hall. Named as Raleigh's first "intendent of police," or mayor, in 1795, he also served as the state treasurer for North Carolina for 40 years. He died in 1827 at the age of 72 after a lifetime of public service to the state and its new capital. (Courtesy Haywood Hall.)

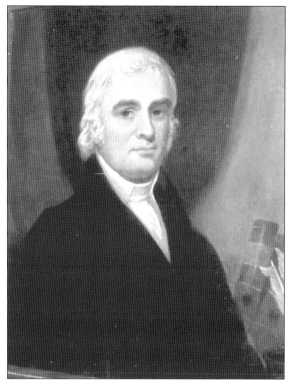

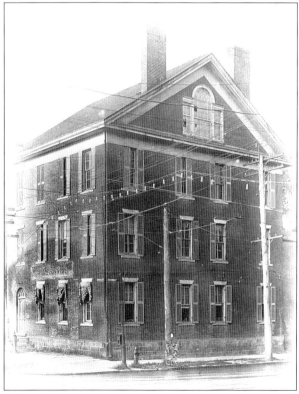

Built originally as the Bank of New Bern in 1818 on the southwest corner of Fayetteville and Morgan Streets across from the statehouse, this stately brick building later became the home of Dr. Fabius Haywood, son of John Haywood. The younger Haywood, a renowned physician, lived here until the 1880s. The house was demolished in 1911. (Courtesy Office of Archives and History, Raleigh.)

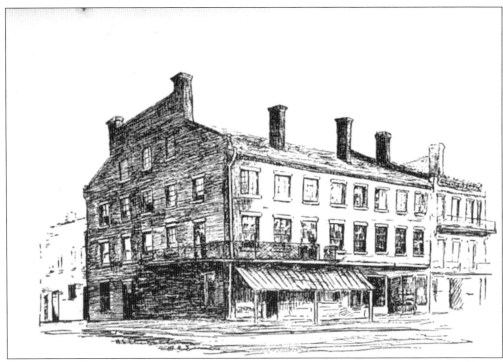

In 1795, French immigrant Peter Casso opened Casso's Inn at the corner of Fayetteville and Morgan Streets. The tavern, located in the heart of the new city, was popular with both residents and travelers. The inn was also the birthplace in 1808 of future president Andrew Johnson. Destroyed by fire in 1833, it was replaced in 1835 by the Hogg-Dortch Building depicted here. (Courtesy Office of Archives and History, Raleigh.)

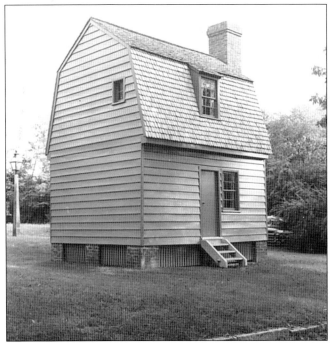

This small outbuilding now located in Raleigh's Mordecai Historic Park once stood behind Casso's Inn. It is believed that Jacob Johnson's wife, Polly, gave birth to a son here on December 29, 1808. That son, named Andrew, later became the 17th president of the United States. The building served as a kitchen, with living quarters on its second floor. (Courtesy Office of Archives and History, Raleigh.)

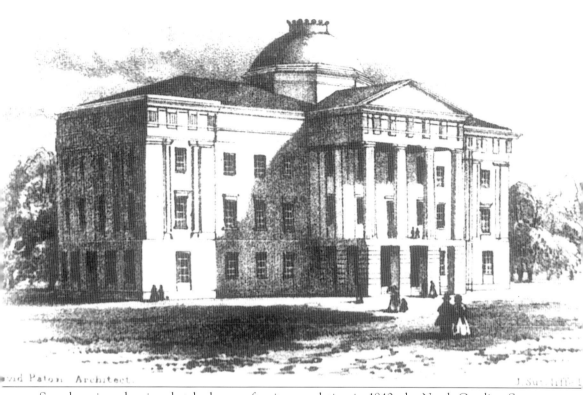

Seen here in a drawing sketched soon after its completion in 1840, the North Carolina State Capitol is the second statehouse to stand on Union Square. On the morning of June 21, 1831, a fire destroyed the original statehouse completed in 1794. The citizens of Raleigh were devastated by the loss, but the controversy that arose from it dismayed them even more. Rather than rebuild in Raleigh, some North Carolinians felt this was an opportunity to move the capital elsewhere. For 18 months, the citizens of Raleigh waited anxiously as a great debate raged over whether or not their city would remain the state's capital. Finally, in December 1832, the issue was resolved. The General Assembly agreed to maintain Raleigh as the state's capital and to begin work on a new statehouse immediately. The new capitol building was finished in June 1840 and still stands today. (Courtesy Office of Archives and History, Raleigh.)

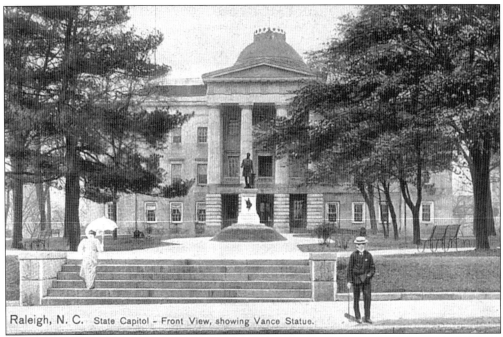

North Carolina's State Capitol is depicted here on a postcard dating from the early 1900s. It remains one of the finest and best-preserved examples of a Greek Revival–style major civic building in the United States. Located in its rotunda is a replica of an earlier Antonio Canova statue of George Washington that was lost in the original statehouse fire of 1831. (Courtesy Raleigh City Museum.)

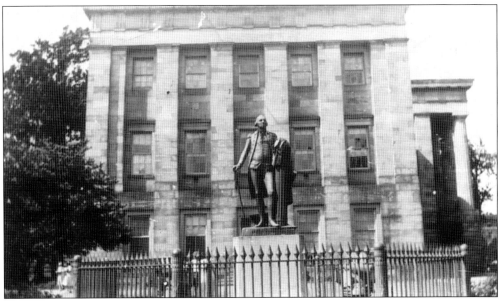

Union Square not only contains the North Carolina Statehouse but many memorials and statues erected to remember both great Americans and great North Carolinians of the past. This southern view of the State Capitol shows a monument to the nation's first president, George Washington. (Courtesy Office of Archives and History, Raleigh.)

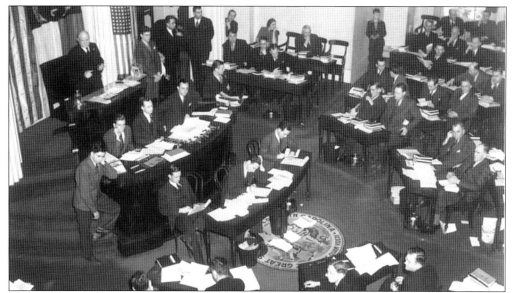

The 1840 statehouse was the meeting site for North Carolina's General Assembly until 1962 when the legislature moved to the new State Legislative Building on Jones Street. Here, the House Chamber debates a tax bill during the 1941 session in the statehouse. The governor still maintains an office in the building. The chambers are now preserved and open to the public. (Courtesy Office of Archives and History, Raleigh.)

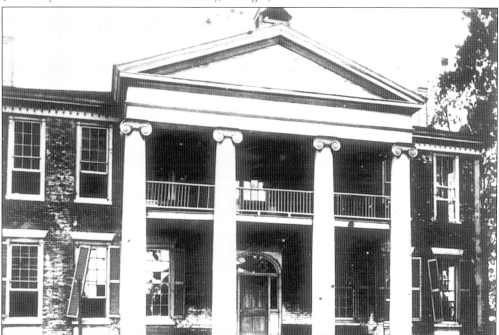

The first governor's residence was constructed on the corner of Fayetteville and Hargett Streets in the 1790s. By 1816, a new Governor's "Palace" opened at the end of Fayetteville Street. Occupied by Union troops during the Civil War and therefore considered tainted, it was no longer used as a residence and became a school. The building was razed in 1885. (Courtesy Office of Archives and History, Raleigh.)

Mordecai House, originally built c. 1785 and added to in 1826, still stands as a Greek Revival–style manor house northeast of downtown Raleigh. Once the heart of an extensive antebellum plantation, a portion of its grounds have become a historic city park that includes the birthplace of Andrew Johnson, the 17th president of the United States, and other buildings from Raleigh's early days. (Courtesy Capital Area Preservation, Inc.)

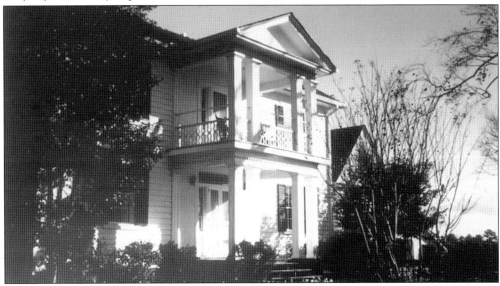

Oak View, an 1850 antebellum farmhouse located east of Raleigh, is now open as one of Wake County's historic parks. Devoted to interpreting agricultural and rural heritage, it includes three on-site museums that interpret the history of cotton, farm life, and the original house. (Courtesy Historic Oak View County Park.)

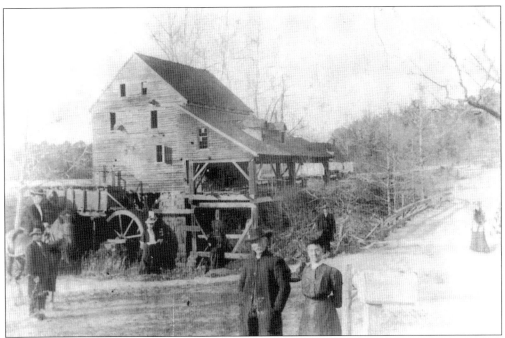

Of the many gristmills that once served Raleigh, Yates Mill is the only one still standing. The water-powered gristmill, where farmers would bring their wheat and corn to be ground into flour, was once an important economic and social center for local residents. The mill, which dates back to the 18th century, is being restored to become a Wake County historic park. (Courtesy Office of Archives and History, Raleigh.)

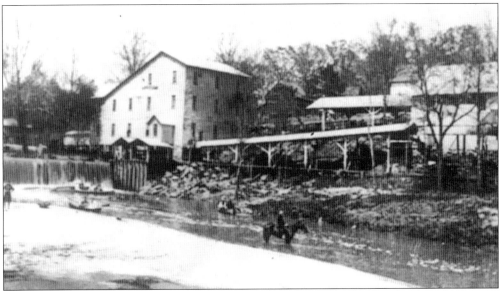

The "Great Falls of the Crabtree" was the site for a succession of mills as early as 1778. In 1908, Cornelius J. Lassiter purchased this mill site and built the gristmill seen here, using two 40-horse turbine wheels to generate power to mill wheat, corn, and later, lumber. Destroyed by fire in 1958, the mill site is still owned by the Lassiter family today. (Courtesy Office of Archives and History, Raleigh.)

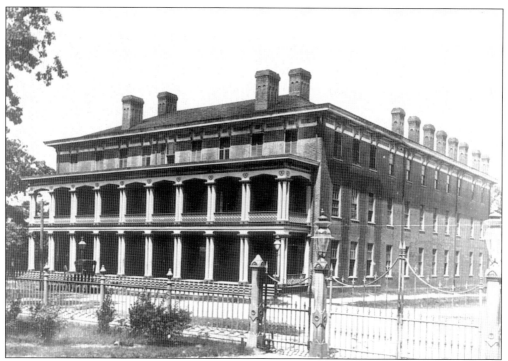

Opened in 1812 on Edenton Street, the Eagle Hotel was Raleigh's first major hostelry. After the Civil War, it was briefly used for homeless, free African Americans. In 1881, the hotel became the Department of Agriculture and site of the State Museum (now the North Carolina State Museum of Natural Sciences). It was demolished in 1922 for the new Agriculture Building. (Courtesy Office of Archives and History, Raleigh.)

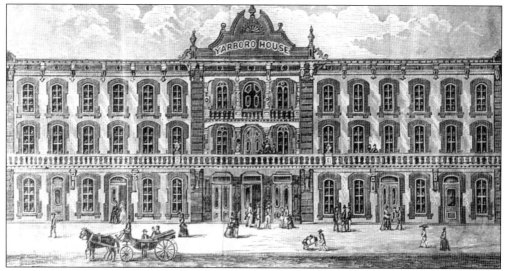

Opened in 1850 on Fayetteville Street, the Yarborough House succeeded the Eagle Hotel as Raleigh's premier inn. Depicted here in a 19th-century lithograph, it became a gathering place for Raleigh socialites and distinguished travelers. After Union troops occupied the Governor's Palace during the Civil War, North Carolina's governors chose to live at the Yarborough rather than the "soiled" official residence. (Courtesy Office of Archives and History, Raleigh.)

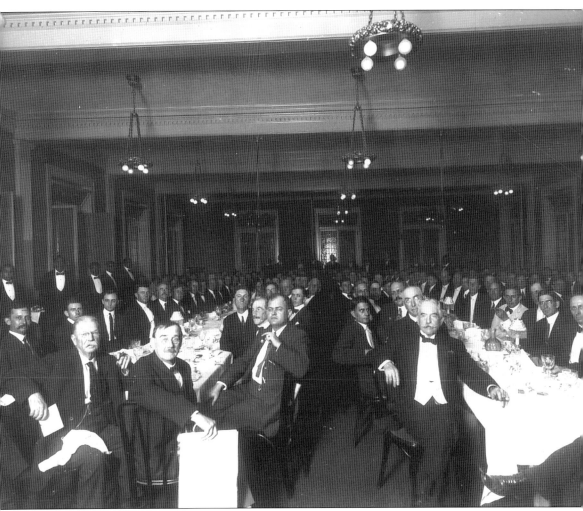

Seen here, guests dine at a banquet held at the Yarborough House in 1900. A 1920s newspaper description reflected upon the modernization of the Yarborough House since its opening 70 years before. "The dining room has a seating capacity of 150 guests, and, with its snowy napery, shining silver and glass, is a most attractive spot. Every delicacy of the season is served here, and the culinary and cooking department is up to date in every respect." National political figures such as Stephen A. Douglas, Andrew Johnson, William Jennings Bryan, Theodore Roosevelt, William Howard Taft, and Woodrow Wilson all stayed at the Yarborough. (Courtesy Office of Archives and History, Raleigh.)

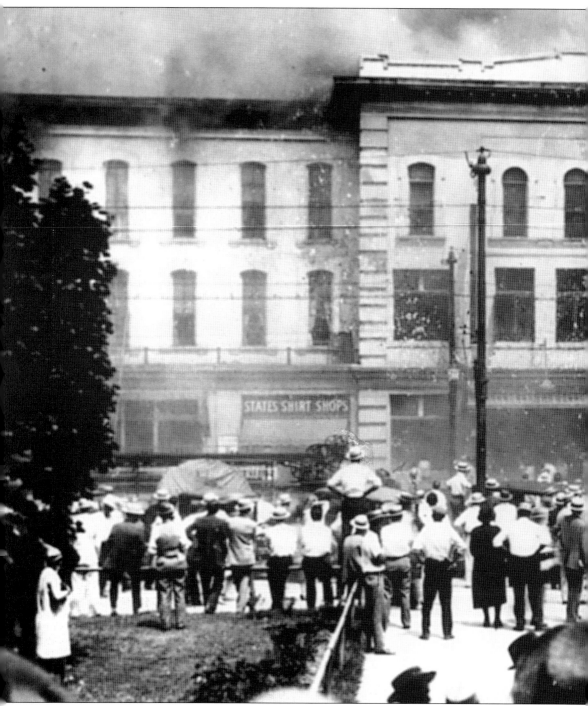

In the 1920s, wives of North Carolina General Assembly members also made Yarborough House their preferred gathering place. The "Yarborough Cabinet," as the group was called, sat around the fireplace on the mezzanine floor to discuss issues of interest until 1924, when the wives moved their meetings to the new Hotel Sir Walter constructed across Fayetteville Street. By the mid-1920s, the more modern Sir Walter took the place of the aging Yarborough House

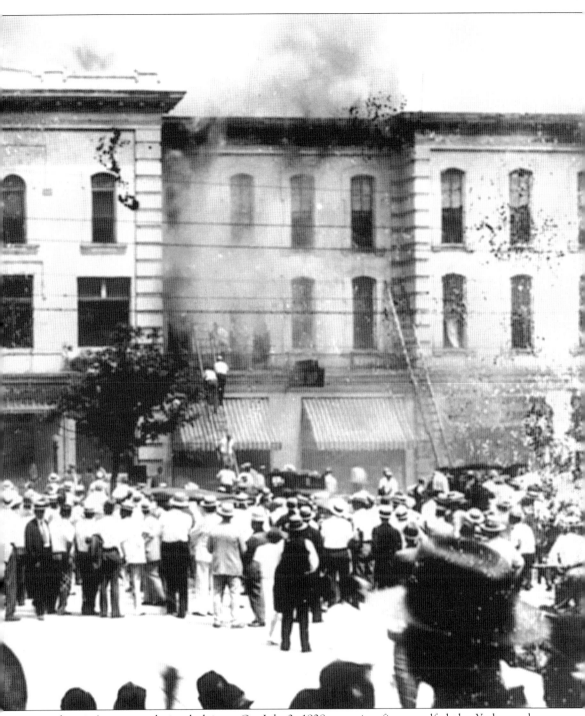

as the city's most exclusive lodgings. On July 3, 1928, a raging fire engulfed the Yarborough House. The building could not be saved and was not rebuilt. Because of the fire, the city lost not only a hotel but also one of its most vibrant social centers. (Courtesy Office of Archives and History, Raleigh.)

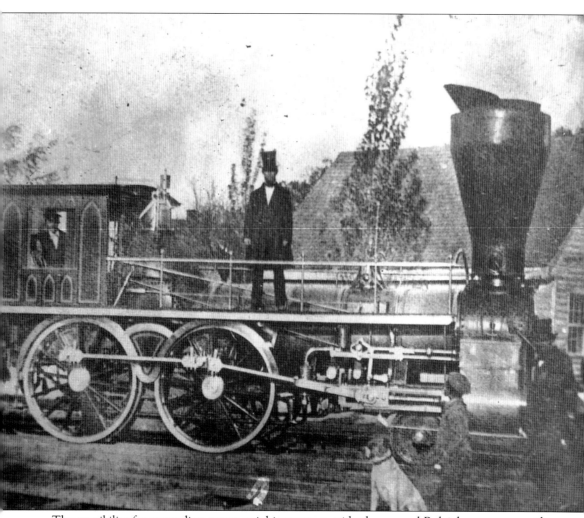

The possibility for expanding commercial interests outside the general Raleigh area came with the arrival of the railroad. The first railroad to serve the city was the Raleigh and Gaston, completed in March 1840. Rails extended 86 miles to Gaston, a Northhampton County town then slightly west of its present location. Later, the line was extended to Weldon, in Halifax County, where passengers and freight could be transferred to other lines proceeding to destinations farther north. By the 1870s, local craftsmen began to build passenger coaches as well as a variety of other cars, including freight, mail, coal, and luggage cars. The Raleigh and Gaston shops and the North Carolina Car Co., which employed 50 men and for a time had the only facilities in the state for manufacturing railroad cars, flourished through most of the 1890s. With the Raleigh and Gaston and subsequent railroads, Raleigh's local business community was no longer isolated. (Courtesy Office of Archives and History, Raleigh.)

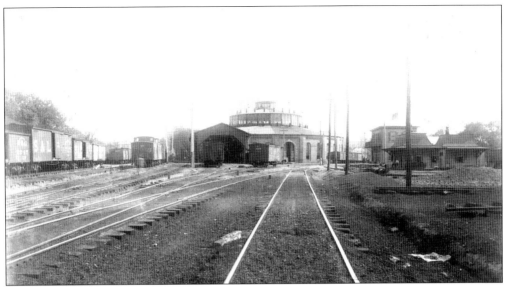

The Raleigh and Gaston's repair shops were a series of roundhouses equipped with individual stalls and work pits for the locomotives. The foundry often caused destructive fires, forcing the railroad to rebuild its shops frequently. The Raleigh and Gaston merged with Seaboard AirLines (later CSX) in 1900 and the roundhouse was demolished in 1968. (Courtesy Office of Archives and History, Raleigh.)

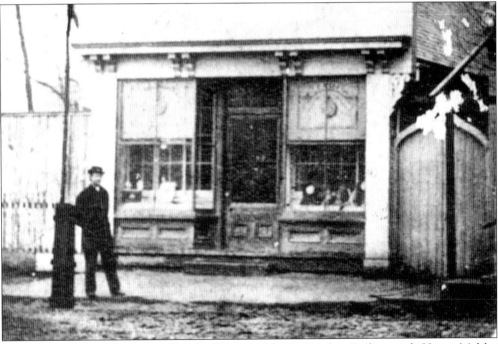

Known for establishing the "Tiffany's of Eastern North Carolina," silversmith Henry Mahler immigrated to Raleigh in the early 1850s from Germany. Specializing in creating and engraving silverware and jewelry, Mahler was also a watchmaker and optician. After his death in 1895, the firm became H. Mahler's Sons and remained in business until about 1932. (Courtesy Office of Archives and History, Raleigh.)

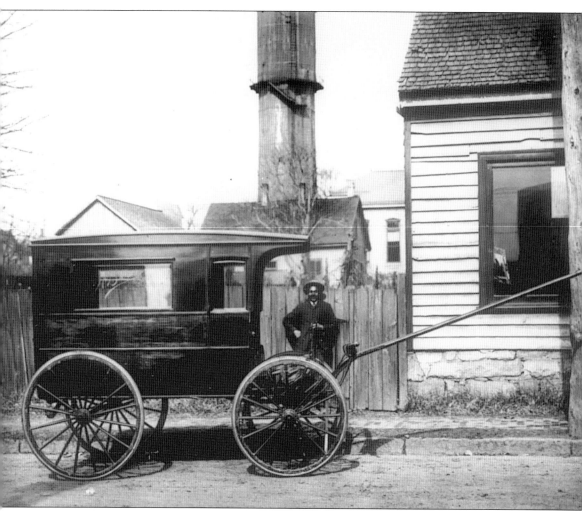

Henry J. Brown, a producer of coffins, burial cases, and undertaking goods, established the H.J. Brown Company, also known as the H.J. Brown Coffin House, in 1836. The business was successively owned by five generations of the Brown and Wynne families for more than 150 years. Throughout that time, the funeral home expanded services, changed location, and remained a mainstay in Raleigh's business landscape. In the late 19th century, H.J. Brown used white horses and carriages for children's funeral processions and black ones for adult funerals. By 1915, owner Fab P. Brown introduced the first motor-driven hearse in Raleigh. Brown-Wynne Funeral Home is considered North Carolina's oldest funeral home and one of the oldest continuous businesses still operating in Raleigh. Seen here c. 1900 is John Brown's hearse. (Courtesy Office of Archives and History, Raleigh.)

Two
From War to Prosperity

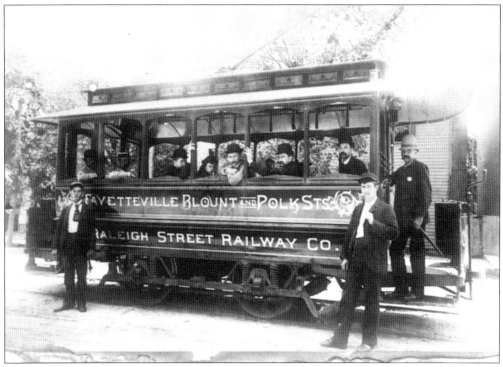

While mules pulled the first streetcars in Raleigh, electric streetcars, like those from the Raleigh Street Railway Co., provided the premier form of public transportation at the end of the 19th century. The streetcars carried people from the business districts around Fayetteville Street to residential areas, including the Polk Street area just north of the original city limits. At this time, Blount Street, running north and south, was one of the more exclusive residential avenues. (Courtesy Office of Archives and History, Raleigh.)

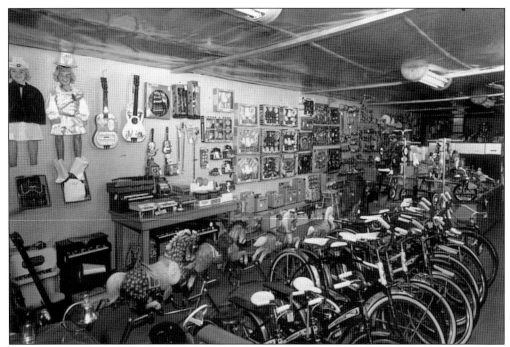

Having founded several building-related enterprises before the Civil War, Thomas H. Briggs and partner James Dodd first opened a hardware store on Fayetteville Street in 1865. After their partnership ended, Briggs erected a four-story building in 1874 at 220 Fayetteville Street. While hardware supplies were the store's staples, bicycles and toys, shown here in the 1950s, also became a Briggs specialty. (Courtesy Raleigh City Museum/Marc Scruggs Jr.)

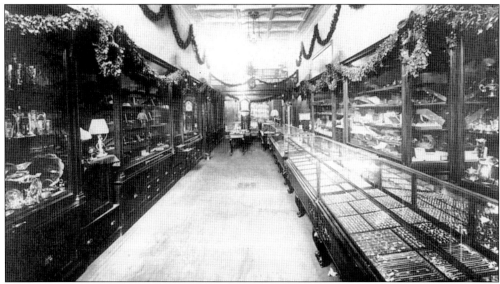

Another well-known local retailer, Benjamin Rush Jolly, established a jewelry business in 1881. Jolly, a jeweler and silversmith, specialized in repairing and selling watches and jewelry. He and his son, Frank M. Jolly, were also registered optometrists. In 1925, the store, located at 128 Fayetteville Street, became known as Jolly's Jewelers. This interior view is c. 1913. (Courtesy Raleigh City Museum/Frank Jolly Ragsdale.)

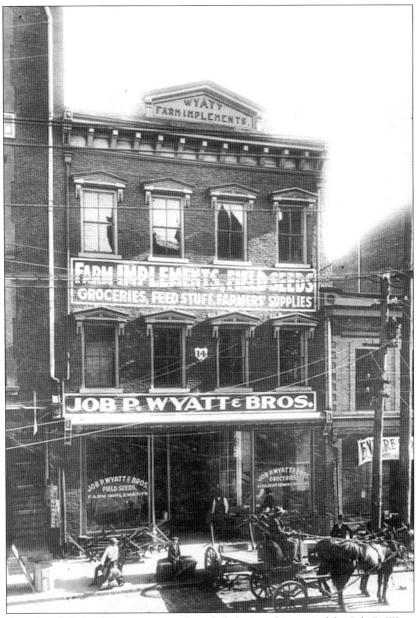

Another long-lived Raleigh business was founded during this period by Job P. Wyatt. Wyatt and Philip Taylor bought the M.T. Norris Co., a dry goods store, in the late 19th century and established Norris, Wyatt, and Taylor. When Norris sold his share of the company in 1883, the store became Wyatt and Taylor. Seven years later, Taylor left for South Carolina, and Wyatt persuaded two of his brothers, Edgar Sidney and Patrick Thomas Wyatt, to join the business. Renamed Job P. Wyatt and Bros., the dry goods store soon expanded to include a wholesale seed business. It occupied the location shown here at 14 East Martin Street until 1912. Wyatt's sons joined the partnership, and the firm became the Job P. Wyatt and Sons Co. As the 20th century proceeded, Job P. Wyatt and Sons increasingly focused on their wholesale seed business. In 1955, the company split into two, forming the Wyatt-Quarles Seed Co. and Job P. Wyatt and Sons. (Courtesy Office of Archives and History, Raleigh.)

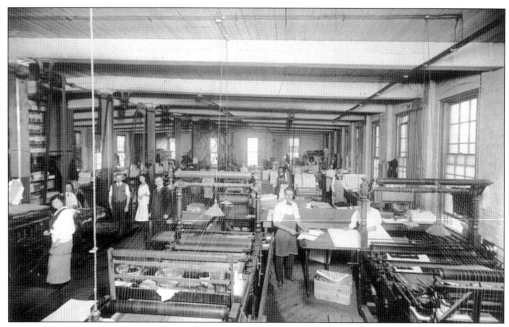

State government helped fuel a growing printing industry in Raleigh. One of the earliest printing enterprises was Edwards and Broughton, established in 1871 on Fayetteville Street. Specializing in printing, stationery, and blank book manufacturing, the company later did bookbinding and copper and steel engraving. This interior view of Edwards and Broughton is from the late 19th century. (Courtesy Raleigh City Museum/Charles Lee Smith III.)

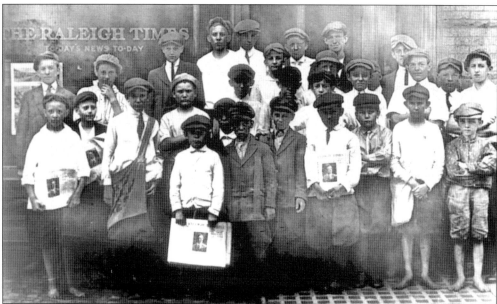

Raleigh's role as the state's capital made it a logical host for newspaper publishers. In 1799, William Boylan moved his Fayetteville *Minerva* press to Raleigh, making it the city's first newspaper. By the late 1800s, Raleigh had many daily and weekly newspapers. One, the *Raleigh Times*, became the city's major afternoon daily. Seen here is a group of *Times* newsboys in 1914. (Courtesy Office of Archives and History, Raleigh.)

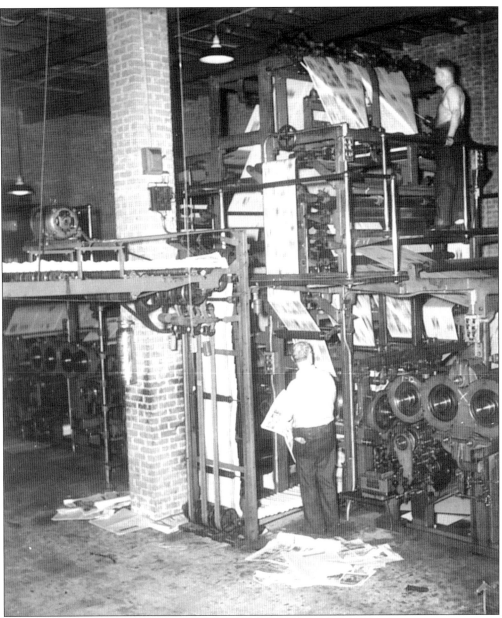

From the plethora of papers published in Raleigh by the end of the 19th century, one would emerge to become the dominant voice of the city—the News and Observer. The roots of the News and Observer go back to the 1870s when two local papers, the Raleigh News (1872) and the Raleigh Observer (1876), were established. In 1880, these two papers merged to form a new publication, the News and Observer (N&O). However, the "modern" N&O was born on August 12, 1894, when the paper came under the ownership of Josephus Daniels. Daniels, a Raleigh native then working as a chief clerk with the Department of the Interior in Washington, purchased the N&O at public auction for $10,000. He was successful in turning around the fortunes of the struggling paper. By the mid-20th century, the N&O was the leading newspaper in eastern North Carolina. Here, the News and Observer's printing plant is seen in 1938. (Courtesy Office of Archives and History, Raleigh.)

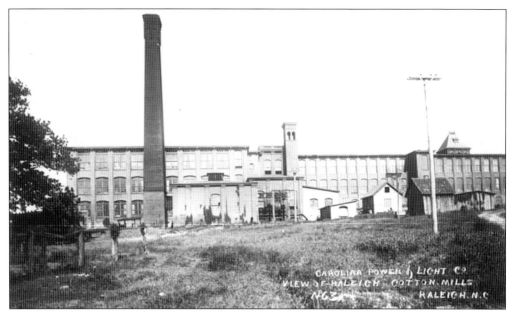

While Raleigh saw a brief period of industrialization during the 1860s, this activity collapsed with the end of the Civil War. Civic leaders encouraged new industrial growth and the Raleigh Cotton Mill, seen here, began operation in 1890. Though initially quite successful, a flooded textile market and labor strikes eventually caused a slow decline in profits and the mill closed in 1927. (Courtesy Office of Archives and History, Raleigh.)

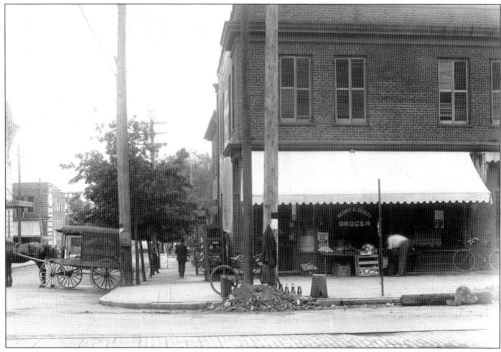

Small businesses were the rule rather than the exception during the early days of Raleigh. Deliveries were made by horse and cart for the Henry G. DeBoy Grocery Store located at the corner of Fayetteville and Davie Streets. (Courtesy Office of Archives and History, Raleigh.)

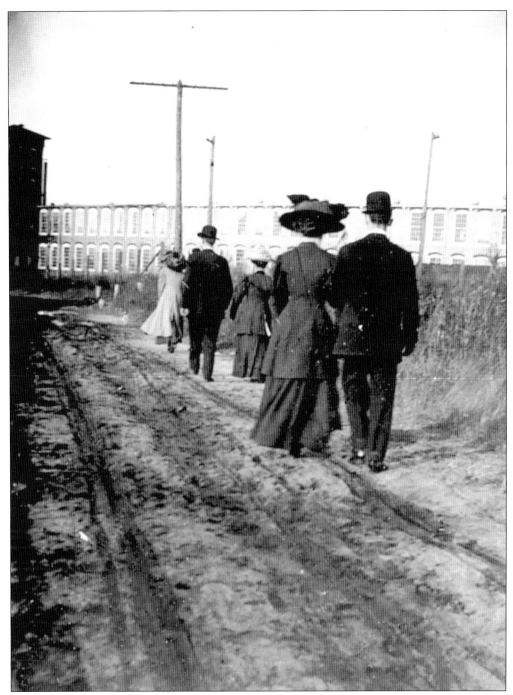

Pilot Cotton Mill was established in Raleigh in 1892 by James N. Williamson and his son, William Holt Williamson. Constructed on a site at 1101 Haynes Street, the mill was annually producing 1.3 million yards of cotton plaid fabric by 1904. In 1919, the mill was sold to a New York firm but was reclaimed by local businessmen in the late 1920s. It continued in active operation until the early 1980s. In this 1909 image, people are walking to the mill site. (Courtesy Raleigh City Museum.)

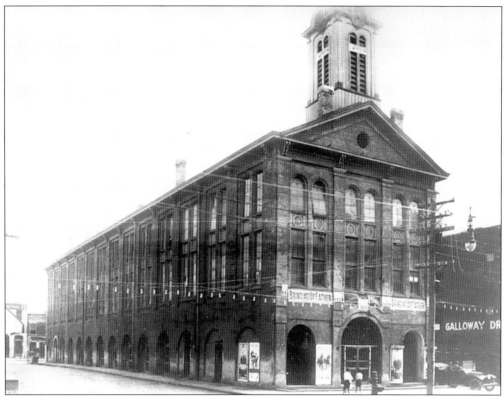

Built in 1870, the Market House, also known as Metropolitan Hall, stood on the corner of Fayetteville Street and Exchange Plaza. The first floor housed stalls for vegetable, livestock, and seafood vendors and was an important economic center of the city. The building also held space for City Hall offices and an auditorium on its upper floors. It was demolished in 1920. (Courtesy Office of Archives and History, Raleigh.)

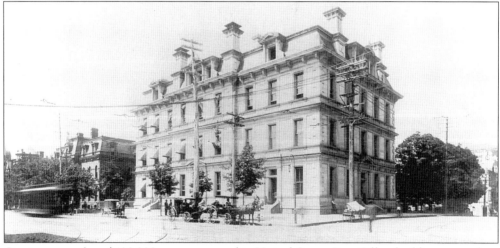

Costing more than $400,000 to construct, this United States Post Office building opened on Fayetteville Street in downtown Raleigh in 1878. Substantially remodeled over the years, the building remains a postal facility and home for other federal and state offices. (Courtesy Office of Archives and History, Raleigh.)

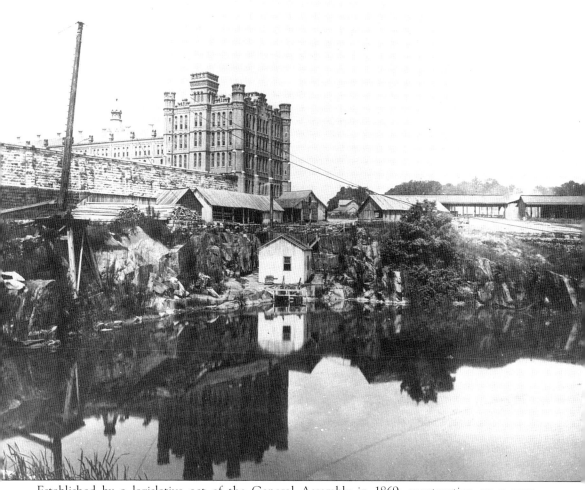

Established by a legislative act of the General Assembly in 1869, construction on a new state penitentiary began in 1870 on a 22-acre site south of Raleigh. Designed by Levi Scofield, the main building followed the "Auburn model," a popular prison design scheme of the day, that incorporated tiered cell blocks behind fortified exterior walls. The structure opened in sections beginning in the mid-1870s. Resembling a medieval European castle with flying buttresses, battlement towers, and parapets, Central Prison was completed in 1884 at a cost of $1.25 million. Its prison population at that time numbered 1,085. W.O. Wolfe, a noted stonecutter and father of novelist Thomas Wolfe, worked on the construction after he came to Raleigh in the 1880s. This view shows the quarry site located near the state penitentiary. (Courtesy Office of Archives and History, Raleigh.)

Beginning in 1910, all capital punishment verdicts were carried out exclusively at the state pen. The prison housed several industries such as a manufacturing plant for license plates and road signs, a printing plant, a paint shop, a shoe repair shop, and a mattress factory. By 1954, the prison structure began to show deterioration and most of its turrets and towers were removed.

In the 1980s, a new prison facility was begun and the original fortress-like structure was taken down. During the demolition process, a time capsule was discovered containing periodicals from the early 1880s. (Courtesy Office of Archives and History, Raleigh.)

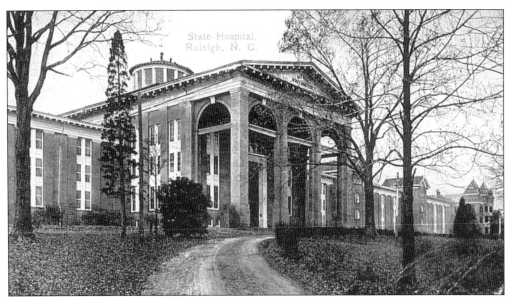

Dorothea Dix, a prominent health-care activist, traveled to Raleigh in 1848 to advocate a state hospital for the insane. That same year, the North Carolina General Assembly passed legislation to establish such a site in Raleigh but the facility did not open until 1856. Located southwest of downtown and later named in honor of Dix, this postcard image shows the main building in the early 20th century. (Courtesy Raleigh City Museum.)

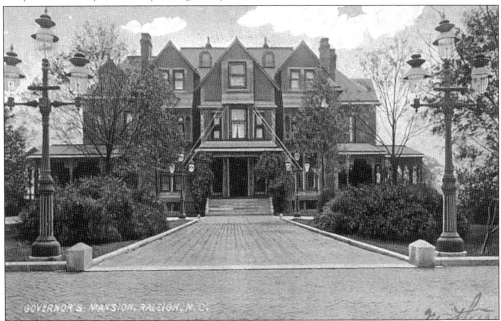

After the Governor's Palace fell into disfavor following the Civil War, North Carolina's governors resided at either the Yarborough House or in their own private homes. That changed when a new Executive Mansion was completed in 1891. Located on the former Burke Square, the house was constructed using prison labor. Seen here in an early 20th-century postcard image, it remains the official home of North Carolina's governors today. (Courtesy Raleigh City Museum.)

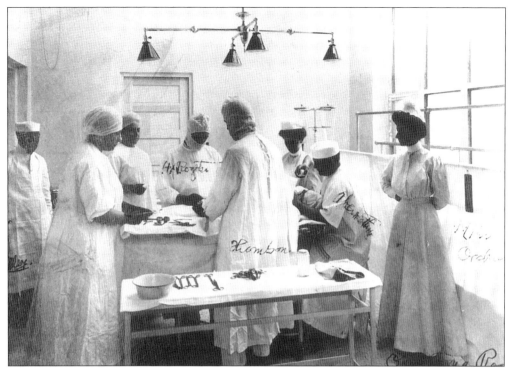

Local philanthropist John Rex bequeathed funds for a hospital in Raleigh upon his death in 1839. The funds were not put to use until 1894 when the former St. John's Hospital was purchased and renamed Rex Hospital. Here, its operating room is seen in 1909. (Courtesy Office of Archives and History, Raleigh.)

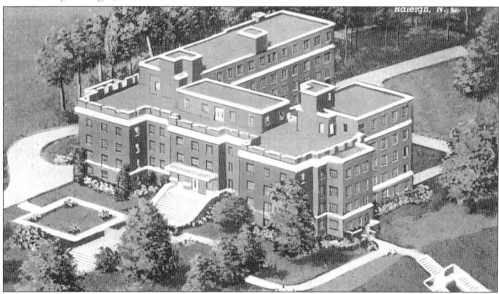

North Carolina's first nursing school later opened at Rex Hospital. The hospital expanded and moved to a modern facility constructed on St. Mary's Street, shown here in a postcard image from the early 20th century. Rex later moved to a larger site on Blue Ridge Road and is now one of the largest health-care facilities in the region. (Courtesy Raleigh City Museum.)

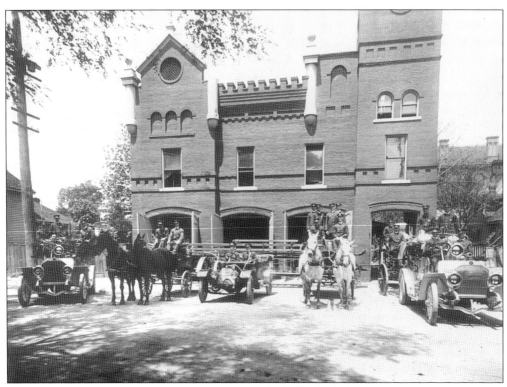

In 1913, the Raleigh Fire Department received its first motorized equipment. By 1915, it was considered "completely motorized" as it converted the Walter R. Womble hook and ladder truck and the L.A. Mahler steam fire engine drawn by motorized equipment. This photograph from 1914 shows Station One with both the old and new equipment. (Courtesy Office of Archives and History, Raleigh.)

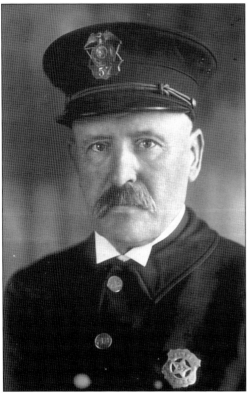

The safety of its citizens has always been a concern for the City of Raleigh. In 1793, the Wake Court appointed a constable and patrollers in Raleigh. Sixty-five years later, Raleigh ended the citizen guard system and hired its first paid watch. Police work was a paid profession by the 1910s when officers like Thomas Barton Alderson, pictured here, served on the force. (Courtesy Raleigh City Museum/Betsy Riddle Dowd.)

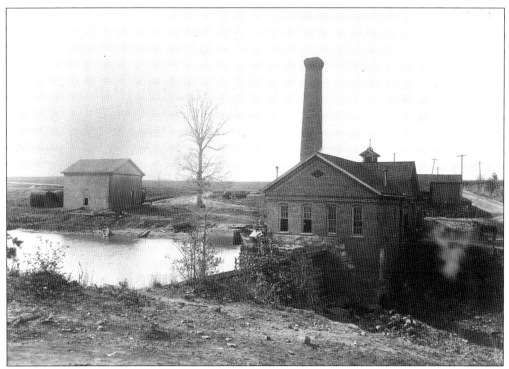
On September 29, 1887 the Raleigh Waterworks completed a water tower on West Morgan Street and installed the city's first large-scale water supply system. Later, Wake County and the City of Raleigh took over the private operation to maintain the water flow to homes and businesses. This photo depicts the Raleigh Waterworks Pumping Station in the late 1890s. (Courtesy Office of Archives and History, Raleigh.)

This early 20th-century postcard image is of the Confederate Soldiers Home in Raleigh. Built in the late 1800s to house veterans of the Civil War, the home was operated in a complex of buildings constructed off New Bern Avenue east of downtown in an area that once contained the first state fairgrounds. The facility closed in 1933. (Courtesy Raleigh City Museum.)

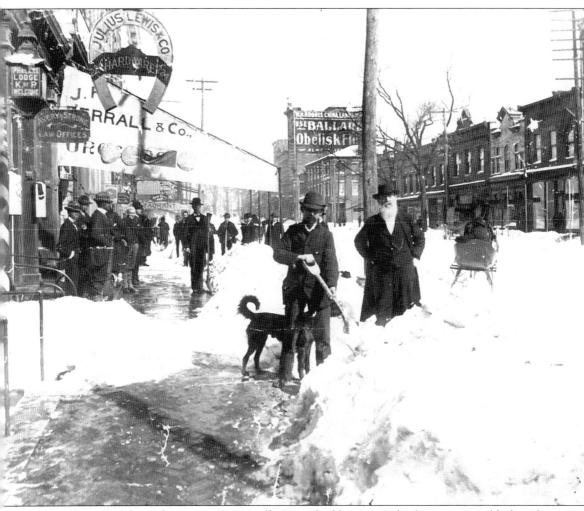

By the end of the 19th century, Fayetteville Street had become Raleigh's commercial hub and a mecca for both local shoppers and out-of-towners. Here, merchants along the 200 block struggle to remove snow left by the Great Blizzard of 1899. At 17.7 inches, the storm held the area's all-time snowfall record until 1927. (Courtesy Office of Archives and History, Raleigh.)

Three
THE HEYDAY OF DOWNTOWN

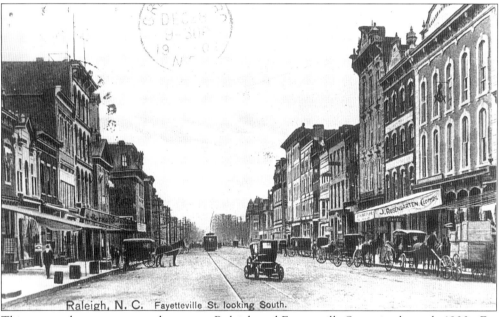

This postcard scene captures downtown Raleigh and Fayetteville Street in the early 1900s. For the first half of the 20th century, Raleigh was still a small, centralized city and most people lived within easy access of downtown. Almost everything that had to do with business—retail, banking, doctors and dentists, personal services, entertainment—could be found downtown. For families outside the community, a day in downtown Raleigh was a major outing—shopping in the many stores along Fayetteville Street, catching the latest motion picture, or standing on the sidewalk watching a holiday parade. African Americans also flocked to downtown but segregation and Jim Crow laws forced their businesses to cluster on East Hargett Street. This separate world became a destination for African-American residents, students, and visitors alike. (Courtesy Office of Archives and History, Raleigh.)

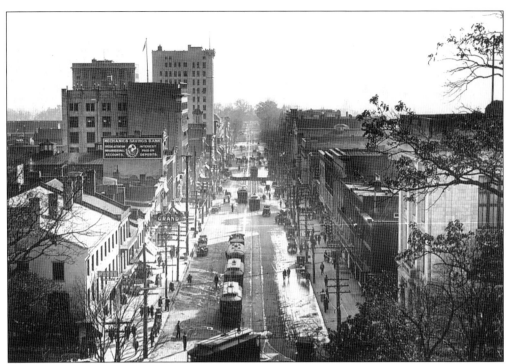

Streetcars, powered by electric rails, provided transportation to the center of Raleigh's urban district. This turn-of-the-century view looking south down Fayetteville Street was probably taken from an upper floor or the roof of the State Capitol building. (Courtesy Office of Archives and History, Raleigh.)

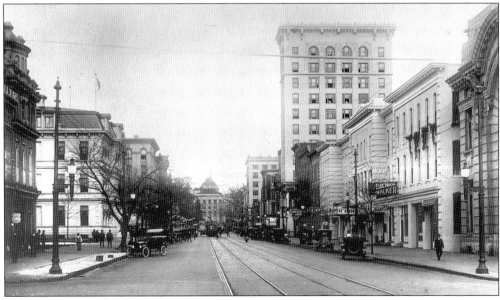

This view is looking north on the 300 block of Fayetteville Street, c. 1910s. On the left side are the Pullen Building and the Century Post Office. The State Capitol stands in the far center and the 10-story Citizens Bank building, the Yarborough House, and, at the far right, the 1911 Municipal Building flank the street. (Courtesy Office of Archives and History, Raleigh.)

This postcard image shows Alfred Williams and Co. at 119 Fayetteville Street. Established around 1867, this store was a popular bookseller and stationery shop that also published books. In the 1940s, the company changed its focus to deal more in office furniture, supplies, and machines. (Courtesy Office of Archives and History, Raleigh.)

This photo from the 1920s captures employees of the Boylan-Pearce department store standing outside its location at 216–218 Fayetteville Street. Established in 1899 when James Boylan and J. Burrell Pearce partnered with Charles McKimmon and E.R. Northam to open a dry goods store, Boylan-Pearce was once one of many fashionable department stores downtown. (Courtesy Office of Archives and History, Raleigh.)

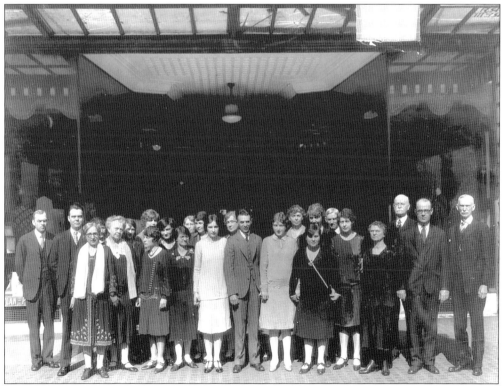

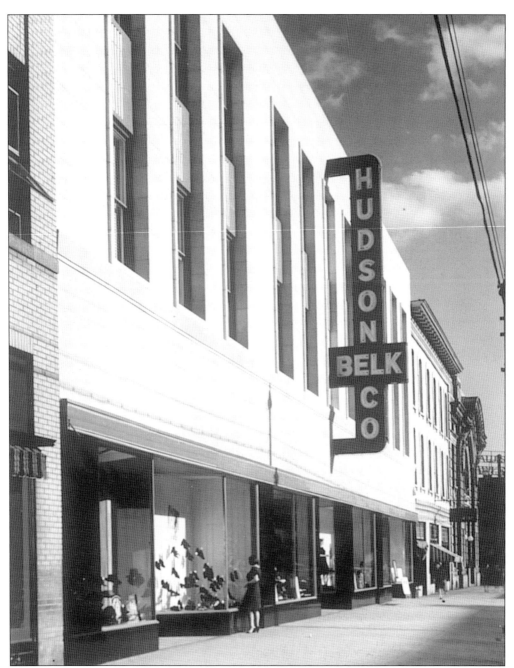

Hudson-Belk was another popular Raleigh department store. The business was begun in September 1915 by Karl G. Hudson Sr. and his brothers, Will and Grier. Their shop on East Martin Street quickly built a reputation as the "Big, Busy Store." As Raleigh came out of the economic depression of the 1930s, the Hudson family planned an expansion on the adjoining site of the former Yarborough House. In 1940, the new Hudson-Belk building, seen here, opened on the 300 block of Fayetteville Street and featured such modern advances as fluorescent lighting and two self-leveling elevators. The company eventually expanded to newer suburban locations and closed their downtown store in 1995. (Courtesy Greater Raleigh Chamber of Commerce.)

Standing at 14–20 East Martin Street, the Commercial National Bank building's cornerstone was laid on October 22, 1912. Ten stories tall, it briefly reigned as Raleigh's tallest structure until Citizens National Bank erected a slightly higher skyscraper in 1913. The building was demolished in 1991. (Courtesy Raleigh City Museum.)

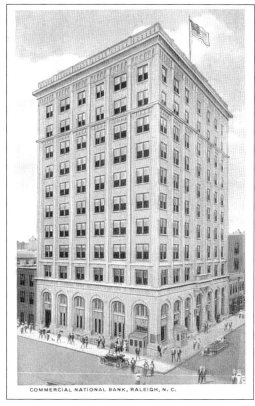

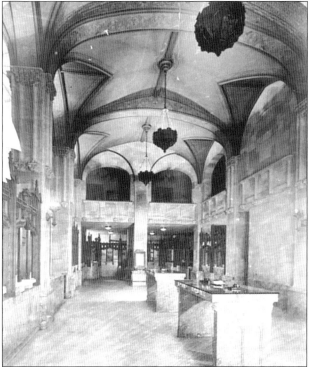

This interior view of the commercial national bank, taken in the early part of the 20th century, shows the dramatic Gothic-Revival design employed by the structure's Atlanta-based architect, P. Thornton Marye. Marye was also responsible for Raleigh's 1911 Municipal Building and Auditorium, the Citizens National Bank building, and the 1915 Wake County Courthouse. (Courtesy Office of Archives and History, Raleigh.)

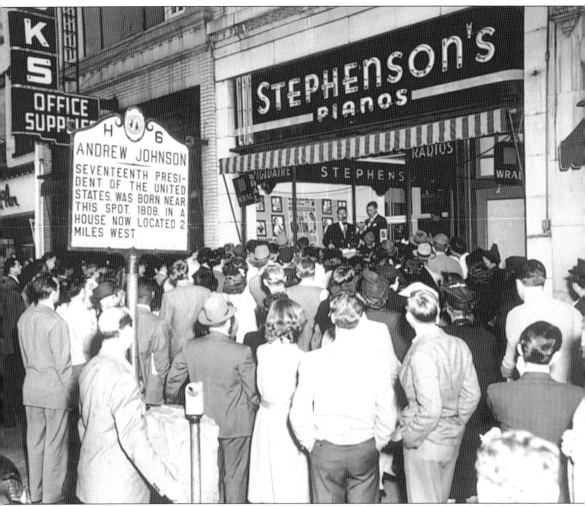

Charles H. Stephenson founded Stephenson's Music Co. in 1907 as a variety store specializing in musical instruments. It had several downtown locations before moving to 121 Fayetteville Street in 1930. From then until 1950, Charles Stephenson Jr. booked most of the classical concerts at Memorial Auditorium and tickets to these events were sold at the store. Stephenson's also featured regularly scheduled musicians who played in its storefront window. This 1940s performance by Stan Kenton was broadcast live over WRAL radio. (Courtesy Raleigh City Museum/Mabel Duke Weeks.)

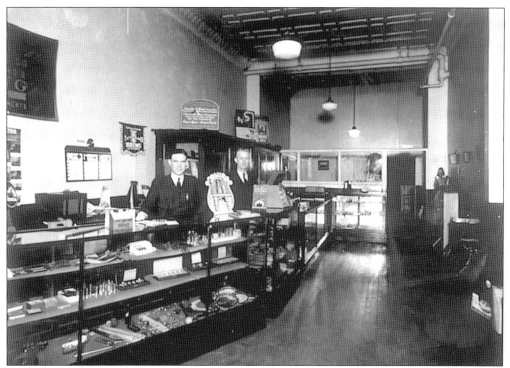

Another well-known music company in Raleigh was Braxton's Music located on Martin Street. In this interior view of 1938 are, from left to right, employee Willard Burrage and owner Sam Braxton. Burrage and his wife, Lucye, later purchased another music store, Gupton's, in the 1950s and renamed it the Burrage Music Co. (Courtesy Raleigh City Museum/Burrage Music Co.)

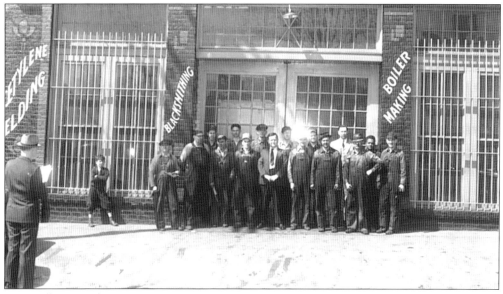

Originally opened in 1914 on West Martin Street, the Dillon Supply Company moved to its long-term location on West Street in 1918. Serving as a mill supplier, Dillon Supply expanded to include offices in three other states. This photo shows some of the company's employees standing outside its operation c. 1930s. (Courtesy Office of Archives and History, Raleigh.)

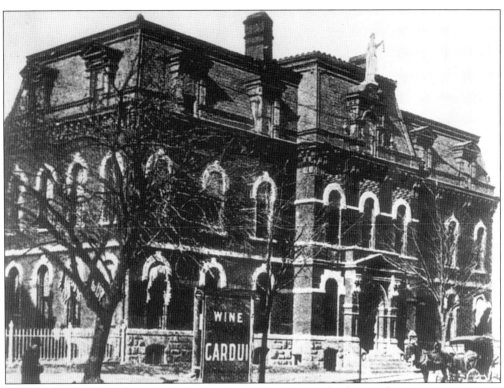

The first Wake County Courthouse actually located in Raleigh was completed in 1795 on the 300 block of Fayetteville Street. An 1832 fire destroyed this building and a new courthouse was erected on the same site in 1837. This courthouse, seen here after its 1883 remodeling, saw occupation by the Union Army during the Civil War. It was replaced in 1915. (Courtesy Office of Archives and History, Raleigh.)

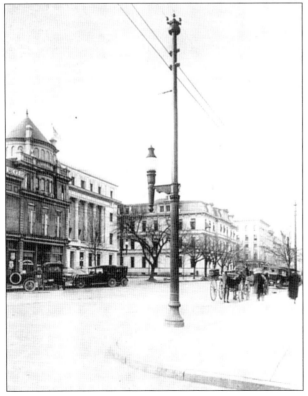

This picture shows the west side of the 300 block of Fayetteville Street as it looked in 1917. Taken from Davie Street, it captures, from left to right, the Pullen Building, the 1915 Wake County Courthouse, and the Century Post Office building. Note the intricately designed electric street lamp on the corner. (Courtesy Office of Archives and History, Raleigh.)

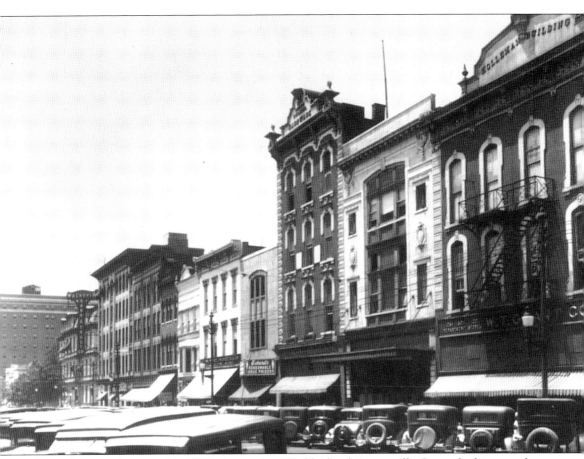

This photograph from the 1920s shows the 200 block of Fayetteville Street looking south along the west side of the street. Stores along this block included Eckerd's, Briggs Hardware, Boylan Pearce, and W.T. Grant and Co. As the main north-south artery, Fayetteville Street was Raleigh's commercial core for nearly 150 years. (Courtesy Office of Archives and History, Raleigh.)

This aerial view of downtown Raleigh looking northward up Fayetteville Street to Union Square and the statehouse was taken in the mid-20th century. This century brought with it many changes to the city. Raleigh's first movie theaters, radio stations, and automobile dealerships appeared in the 1910s and 1920s. The Great Depression of the 1930s forced a

number of local companies out of business. World War II saw Raleigh businesses support the war effort and lose a number of male employees to the Armed Forces. As the war ended by mid-century, the role of downtown as the driving force of Raleigh's commercial life came to a pinnacle. (Courtesy Greater Raleigh Chamber of Commerce.)

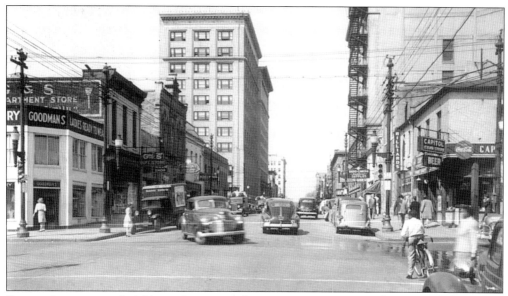

Segregation prevented African Americans from patronizing many white-owned downtown establishments and from opening businesses on Fayetteville Street. In response African Americans opened businesses that catered to a largely black clientele, first on Wilmington and then on East Hargett Street. This view looks west at the intersection of Wilmington and East Hargett streets, c. 1940s. (Courtesy Office of Archives and History, Raleigh.)

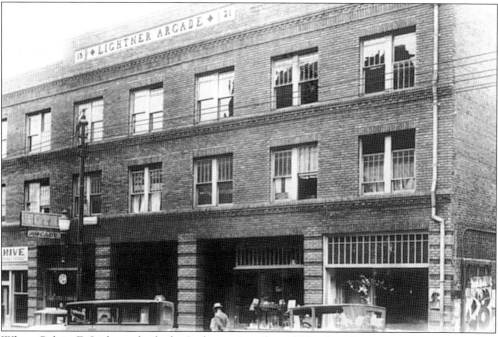

When Calvin E. Lightner built the Lightner Arcade and Hotel on East Hargett Street in 1921, it quickly became the center of activity for Raleigh's African-American community. During its heyday, it was considered one of the premier hotels for African Americans on the East Coast. Its ground floor housed a restaurant, drugstore, barbershop, and *The Carolinian* newspaper office. (Courtesy Office of Archives and History, Raleigh.)

P.R. Jervay rented office space in the Lightner Arcade. In 1940, he moved to Raleigh from Wilmington and purchased the *Carolina Tribune*, a local black newspaper. He transformed the *Tribune* into *The Carolinian* and provided his African-American readers with stories overlooked by white-owned newspapers. Here, Jervay shows *The Carolinian's* printing press to his mother, Mary Alice Jervay, c. 1941. (Courtesy Raleigh City Museum/Prentiss Jervay Monroe.)

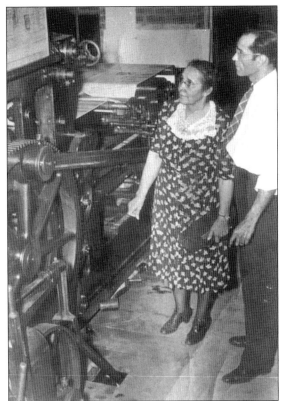

In this photo, E. Reginald Swain is shown demonstrating a linotype machine at *The Carolinian* in the mid-20th century. Although publisher P.R. Jervay built a network of small papers, he discontinued that practice in the 1950s and concentrated solely on *The Carolinian* in Raleigh. It remains the only African-American newspaper published twice weekly in North Carolina. (Courtesy Raleigh City Museum/Prentiss Jervay Monroe.)

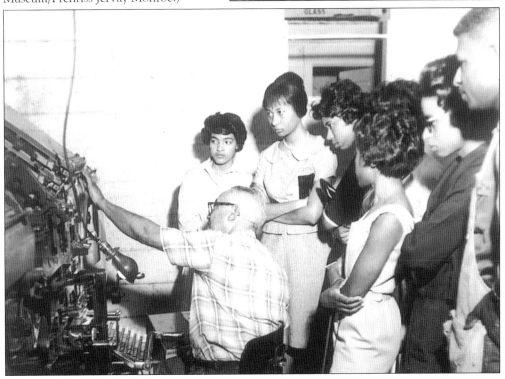

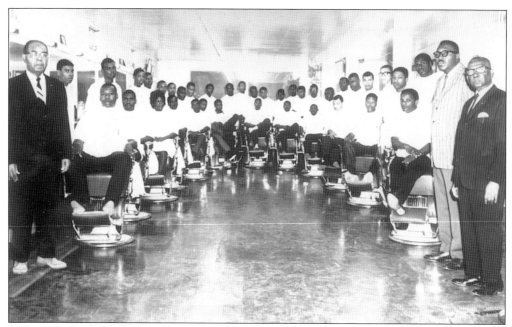

Trade schools and colleges played an important role in teaching African Americans the skills needed to open businesses. Students of the Harris Barber College, established by Samuel Harris in 1930, had the option of living at the school, located first on East Cabarrus Street and later on South Blount Street. This 1960s photograph features instructors and students enrolled at the college. (Courtesy of Raleigh City Museum/Geraldine Harris Burroughs.)

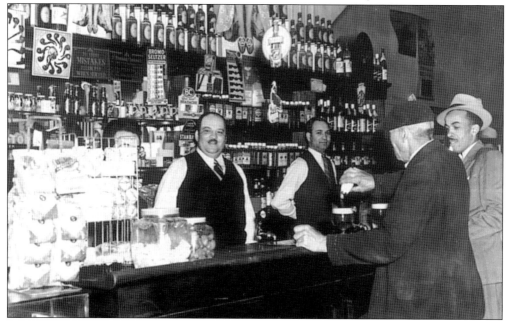

In addition to restaurants and movie theaters, bars and billiard halls created an environment of relaxation and good times. Taylor's Billiards, established by the early 1940s by James Gordon Taylor, was located at 126 East Hargett Street. Charley Otey and owner James G. Taylor are pictured inside Taylor's, c. 1940s. (Courtesy Office of Archives and History, Raleigh.)

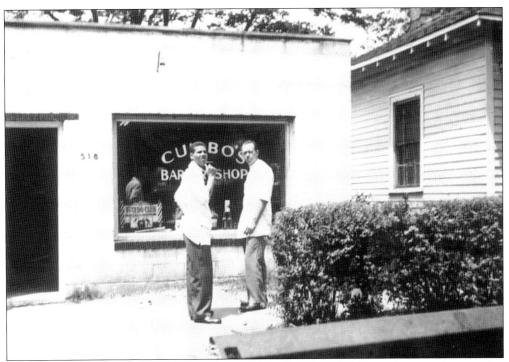

Not all of Raleigh's African-American businesses were found on East Hargett Street. This photograph shows Cumbo's Barber Shop, located at 518 South Bloodworth Street since 1947. (Courtesy Raleigh City Museum/Lawrence T. Williams.)

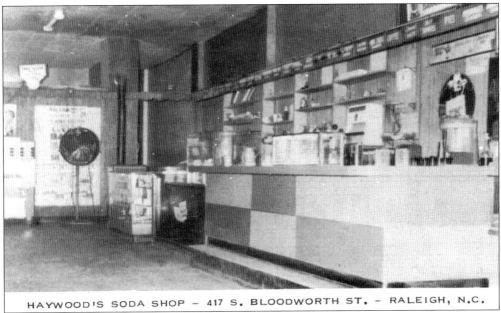

Another popular African-American business in Raleigh was Haywood's Soda Shop, located at 417 South Bloodworth Street. This picture of Haywood's dates back to the mid-20th century. (Courtesy Raleigh City Museum/Lawrence T. Williams.)

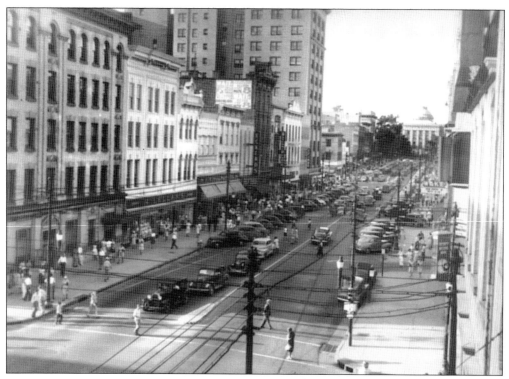

People came to downtown Raleigh for entertainment and to socialize. Moviegoers could choose from a variety of theaters and Raleigh's social scene supported a number of fine hotels. For less formal occasions, bars and billiard halls fit the bill despite many years of prohibition. All this activity kept traffic along Fayetteville Street, seen here in the 1930s, very busy. (Courtesy Office of Archives and History, Raleigh.)

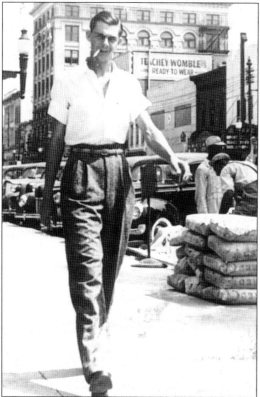

Pedestrian traffic along Fayetteville Street was plentiful in the 1940s. While most walkers had a purpose—to shop, catch a movie, or find a meal—downtown was also a great place for people-watching. Here, Hubert Eugene "Bubba" Riddle Jr. enjoys an afternoon stroll in downtown Raleigh, c. 1940s. (Courtesy Raleigh City Museum/Peggy R. Hopson.)

Four-year-old Sally Blackwell Russell (right) walks with her seven-year-old sister Vivian Blackwell Stainback on Fayetteville Street in 1939 after having their hair done at a downtown beauty school. A street photographer, who took pedestrian pictures for a fee, most likely snapped this shot of the sisters. (Courtesy Raleigh City Museum/Sally Blackwell Russell.)

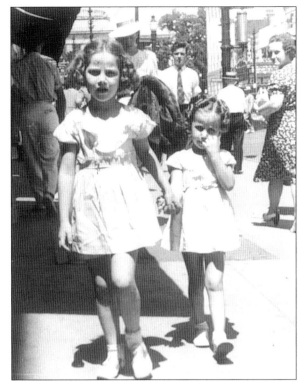

After the last electric trolley ceased running in 1932, buses operated by CP&L dominated the public transportation scene in downtown Raleigh. This bus is loading passengers at the corner of Fayetteville and Martin Streets by the Century Post Office building in 1941. (Courtesy Office of Archives and History, Raleigh.)

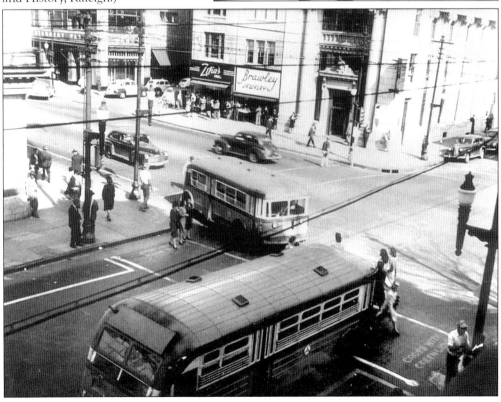

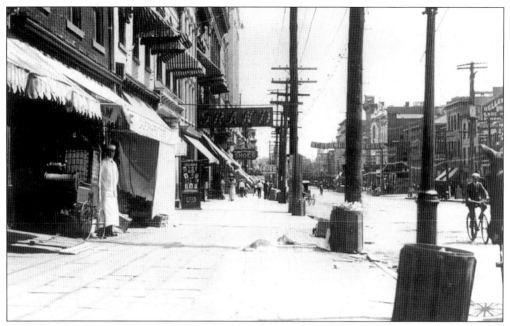

Arguably, the most important new art form of the 1900s was the motion picture. Shortly after the turn of the century, small nickelodeons opened nationwide in former store shops, showing one-reel silent films. One of Raleigh's earliest theaters, the Grand, whose marquee is seen here, opened on the 100 block of Fayetteville Street in 1910. (Courtesy Office of Archives and History, Raleigh.)

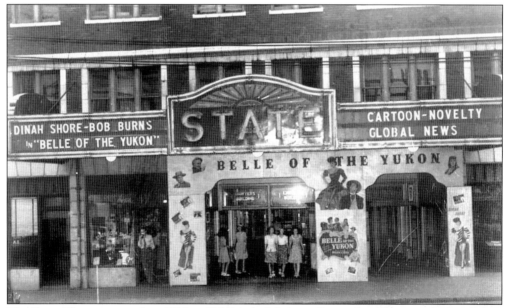

The State Theatre opened in 1924 at 320 South Salisbury Street. In addition to "side-splitting vaudeville," drama, comedy, and minstrel performances, it also showed moving pictures. By 1925, silent films such as Charlie Chaplin's *The Gold Rush* were screened to the accompaniment of piano, organ, or orchestral music provided by local residents. The theater continued to feature both live productions and motion pictures for many years. (Courtesy Raleigh City Museum.)

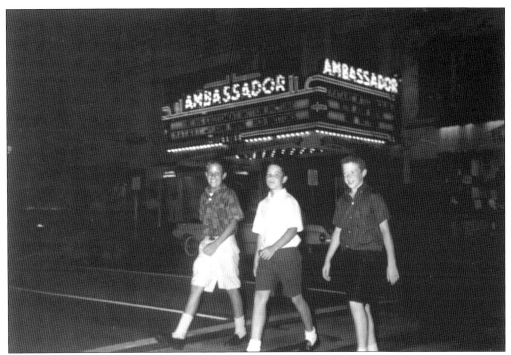

Named to honor *N&O* publisher Josephus Daniels, who served as ambassador to Mexico, the Ambassador Theater opened at 115 Fayetteville Street in 1938. Here, Ted Nowell, Fallon Hanley, and Marshall Wyatt stroll at night in front of the Ambassador's bright marquee in 1962. (Courtesy Raleigh City Museum/Photo by Edgar M. Wyatt.)

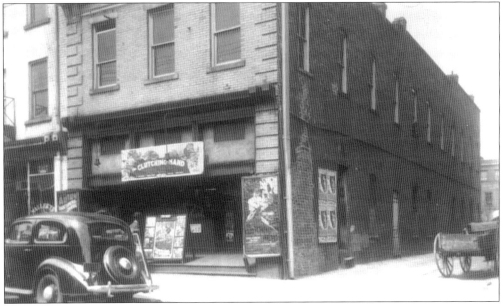

During the era of segregation, most downtown movie houses maintained separate entrances and sections for white and black customers. The Lincoln Theatre, shown here c. 1940s, was located at 126 East Cabarrus Street and catered to African-American moviegoers of this period. (Courtesy Office of Archives and History, Raleigh.)

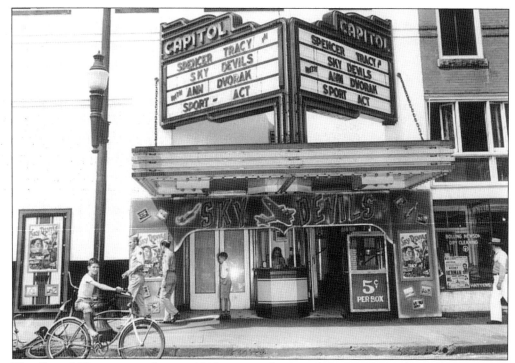

The Capitol Theatre, seen here in 1945, was another popular movie house located at 124 West Martin Street. It was a favorite for Raleigh's young boys as it specialized in action, adventure, and cowboy films. Its Saturday matinees were of special interest to its youthful clientele. (Courtesy Office of Archives and History, Raleigh.)

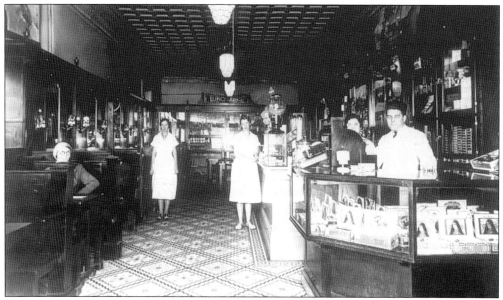

Nicholas John Dombalis, a native of Turkey, opened the Mecca Luncheonette in 1930 at 201 Fayetteville Street. Moving in the mid-1930s to 13 East Martin Street, where it still operates today, the Mecca Restaurant is considered the oldest family-owned restaurant in Raleigh. This interior shot dates to the 1930s. (Courtesy Raleigh City Museum/John Dombalis.)

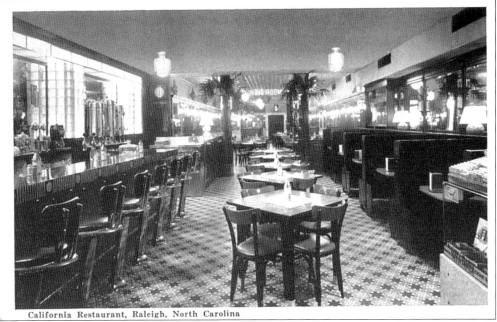

Another busy downtown eatery was the California Restaurant located at 111 Fayetteville Street. Opened as the California Fruit Store at the turn of the century by Alex and Gus Vurnakes, it began as a fruit and confectionery shop and later added a restaurant. This postcard image of its interior is from the mid-20th century. (Courtesy Raleigh City Museum.)

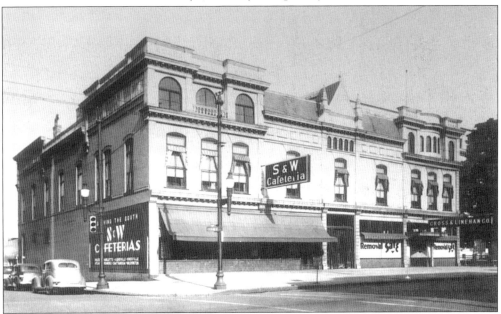

The Pullen Building, seen here c. 1930s, was built in 1894 as a commercial office building on the northwest corner of Fayetteville and Davie Streets. In 1925, the Durham Life Insurance Co. purchased the structure and new tenants included radio station WPTF-AM, the Cross and Linehan Clothing Co., and the S&W Cafeteria, which became an instant destination for hungry shoppers. (Courtesy Raleigh City Museum/R.W. Kennison.)

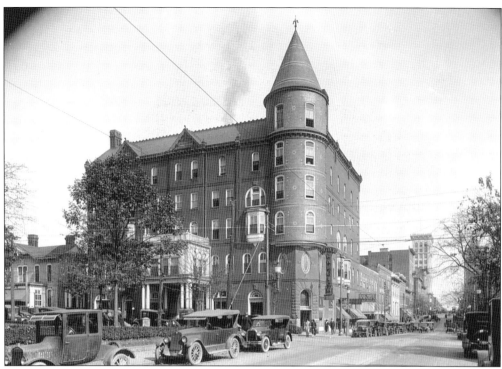

The Park Hotel, opened in 1895 by Frank Page, was located at Martin and McDowell Streets opposite Nash Square. Serving "winter guests only" and some year-round residents, it is said to have been Raleigh's first apartment house. (Courtesy Office of Archives and History, Raleigh.)

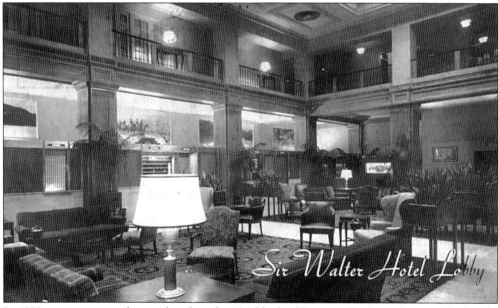

In 1922, construction of a new hotel in the 400 block of Fayetteville Street began. The hotel's stockholders held a contest to find the right name for the capital's newest inn, and the winning entry was "Sir Walter." Opening in 1924, its lobby, seen here in this postcard image, was one of the most fashionable meeting spots in town. (Courtesy Raleigh City Museum.)

The Hotel Sir Walter immediately competed with the Yarborough House as the premier hotel in the city, a competition that ended with the Yarborough House fire of 1928. The Neoclassical Revival–style building then became the prime location for the political activity once hosted by the Yarborough. It became known as "the third house of state government." Famous guests included former presidents Theodore Roosevelt and Harry S Truman, President Lyndon B. Johnson, and Maria von Trapp. When Will Rogers visited in 1928, he conducted a rope-trick demonstration on the hotel roof. The hotel was also a hub of social activity for the residents of Raleigh. The Raleigh Kiwanis Club was the first civic club to hold its weekly meetings in the building and many other civic groups soon followed. Beginning in 1935, the Raleigh Junior Woman's Club held its Valentine Ball in the Sir Walter's Virginia Dare Ballroom. Many of the state's debutante balls were also held there. (Courtesy Office of Archives and History, Raleigh.)

Raleigh's lack of a convention hall led to construction in 1911 of a municipal building and auditorium at the corner of Fayetteville and Davie Streets. The building served two functions, with space for Raleigh's City Hall and an auditorium accommodating 5,000 seats. For 20 years, it hosted events such as grand operas, political conventions, circuses, and A&M (now NC State) basketball games. (Courtesy Office of Archives and History, Raleigh.)

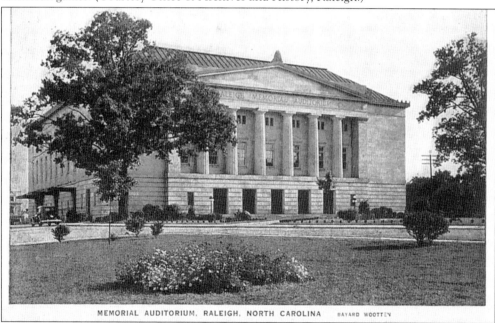

On the evening of October 24, 1930, the Municipal Auditorium caught fire and was completely consumed. Firefighters were able to save the section housing city offices. A new Memorial Auditorium, seen here on an early 20th-century postcard, was quickly constructed at the southern end of Fayetteville Street and opened to much fanfare in 1932. (Courtesy Raleigh City Museum.)

The Lightner Hotel and Arcade provided first-class entertainment for Raleigh's African-American community. Musicians such as Count Basie and Duke Ellington were guests in the hotel and performed in the upper floor of the Arcade. The facility became the most visible symbol of the thriving and distinct African-American district along East Hargett Street. (Courtesy Office of Archives and History, Raleigh.)

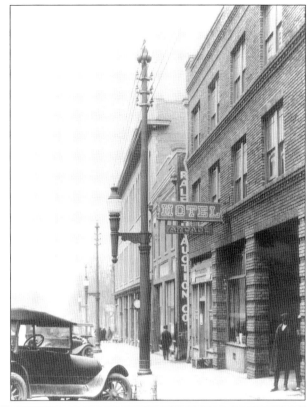

Raleigh played host to a variety of show bands and traveling acts frequently held at Memorial Auditorium, the Hotel Sir Walter, or one of the colleges. Here, T.B. McDowell (standing, far left) and his orchestra pose for a formal photograph. (Courtesy Raleigh City Museum/Leon Jordan.)

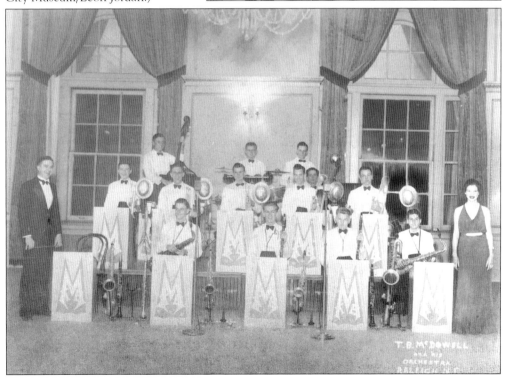

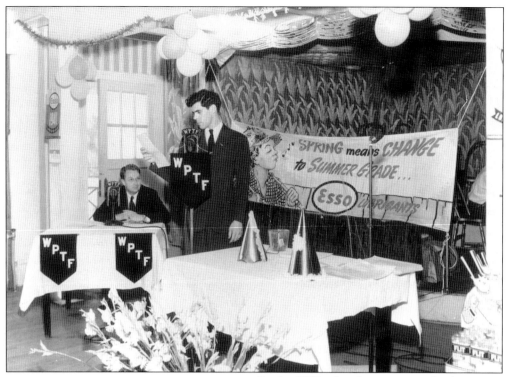

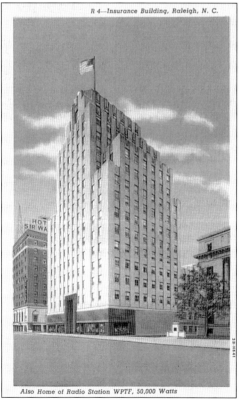

By the 1920s, the phenomenon of radio was thriving nationwide as broadcasting networks aired shows that played in America's living rooms. The first commercial radio station in Wake County began in 1924 as WFBQ-AM. Purchased by the Durham Life Insurance Co. in 1927, it became WPTF, standing for "We Protect the Family," the company's motto. (Courtesy Office of Archives and History, Raleigh.)

The radio station WPTF-AM joined the NBC radio network in 1928. Originally located in the Pullen Building, then the Hotel Sir Walter, it eventually moved to the Durham Life Building on Fayetteville Street in 1942. (Courtesy Raleigh City Museum.)

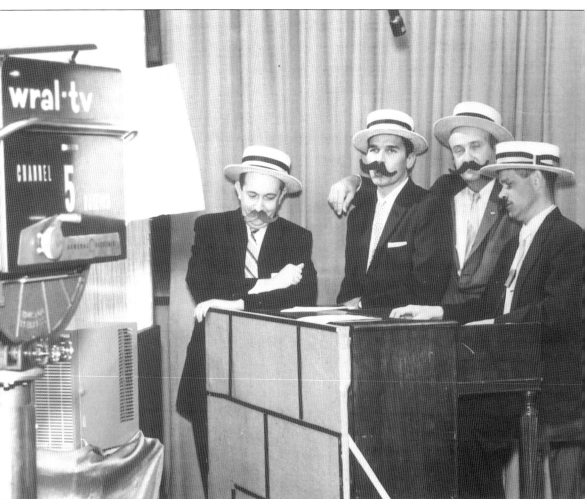

In 1937, A.J. Fletcher received a license to operate a 250-watt radio station. Two years later, WRAL-AM (R-A-Leigh) went on the air, becoming Raleigh's second commercial radio station. In 1946, Capitol Broadcasting Co. received an FM license, creating WRAL-FM, the area's most powerful FM station. The company received a license from the FCC for WRAL-TV (Channel 5) in 1956 after a lengthy hearing before the commission. Raleigh's first television station, WRAL-TV, took a prominent role in the community by providing a means for area residents to learn about current events and other community issues through local programming and CBS-affiliated national programming. Here, local broadcast legend Fred Fletcher (third from left) leads a barbershop quartet in the WRAL-TV studios, c. 1960s. (Courtesy Raleigh City Museum/Capitol Broadcasting Co., Inc.)

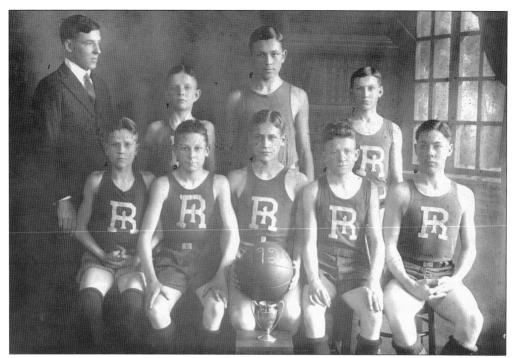

Local sports have played an important role in Raleigh as an entertainment venue. Depicted in this vintage photograph is the Raleigh High School boy's basketball team of 1921. Pictured from left to right are (front row) Phil Howell, Henry Young, Bill Ward, Frank Bell, and Bill Bruner; (back row) coach Garrell Shumaker, Polly Goodwin, Joe Berwanger, and Dick Mason. (Courtesy Raleigh City Museum.)

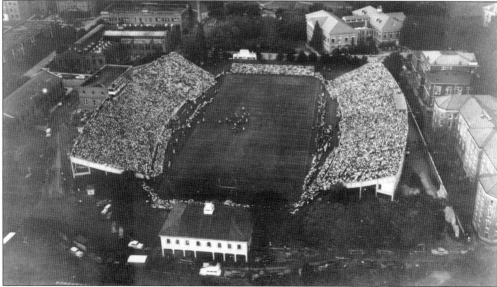

College sports have grown in popularity as local teams formed rivalries with other North Carolina teams. The Wolfpack of NC State became natural rivals of nearby Duke University and UNC-Chapel Hill. This aerial photograph shows the Duke-State men's football game being played in State's Riddick Stadium in 1946. (Courtesy Office of Archives and History, Raleigh.)

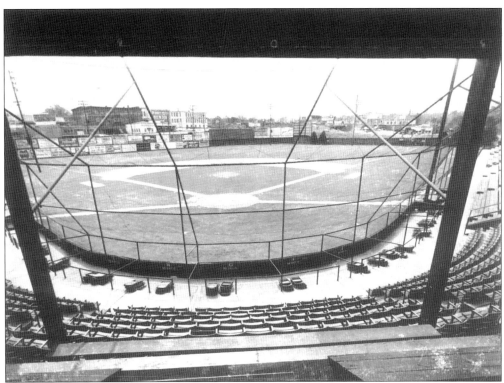

Devereux Meadow Baseball Park was built in 1939 just west of Capital Boulevard. For decades, the ballpark was the only full-sized, lighted baseball field in Raleigh. Teams from Raleigh and other locales played on levels ranging from high school and recreational leagues to professional minor league teams. The popularity of the park waned as it aged and it was dismantled in 1979. (Courtesy Office of Archives and History, Raleigh.)

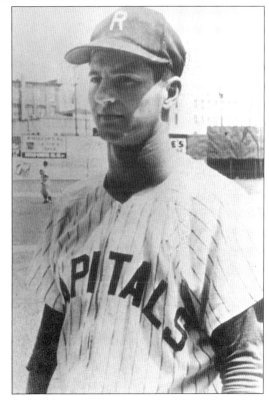

Devereux Meadow was the site of nightly entertainment in the summer. During its heyday in the 1940s, it drew thousands of spectators each night to see the hometown Carolina League Raleigh Caps play. The park hosted a series of pro farm teams. Future big leaguers like Carl Yastrzemski, seen here at the park in 1959, played in Raleigh during their time in the minor leagues. (Courtesy Raleigh City Museum.)

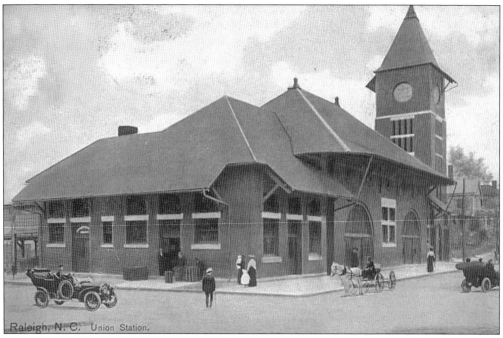

As early as 1840, the city was connected to the rest of the country via the railroad. For many years, Union Station, seen in this vintage postcard from the early 20th century, serviced passengers arriving to and departing from downtown Raleigh. (Courtesy Raleigh City Museum.)

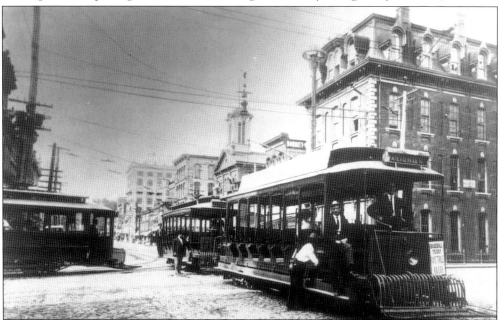

Beginning in the 1880s, downtown streetcars provided an inexpensive means to move about the city. In the early 1900s, the extension of streetcar lines north and west of downtown helped to develop the new neighborhoods of Cameron Park and Hayes-Barton. This car running along Fayetteville Street in the 1890s advertises an upcoming local baseball game. (Courtesy Office of Archives and History, Raleigh.)

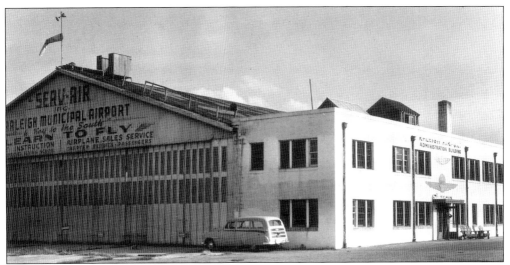

Seven years after the Wright Brothers' flight at Kitty Hawk in 1903, I.A.D. McCurdy landed a plane at the old downtown fairgrounds and the age of flight arrived in Raleigh. The first airport in the area, seen here in the 1950s, opened in 1929 near Route 70 south of town. It serviced the city's aviation needs until the Raleigh-Durham Airport opened on 1,000 acres in the 1940s. (Courtesy Office of Archives and History, Raleigh.)

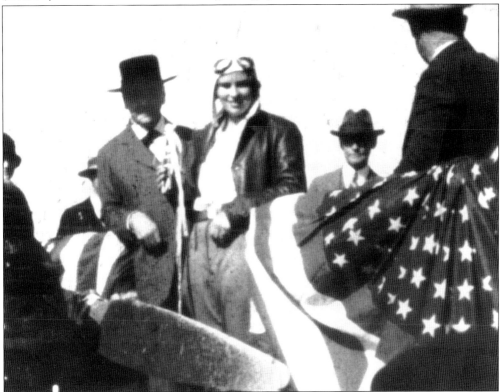

The world of aviation had its own world-renowned celebrities in the 1920s and 1930s. Famed flyer Amelia Earhart landed in Raleigh in the 1930s during an advertising campaign for Beechnut Gum. (Courtesy Raleigh City Museum/Jay Denmark.)

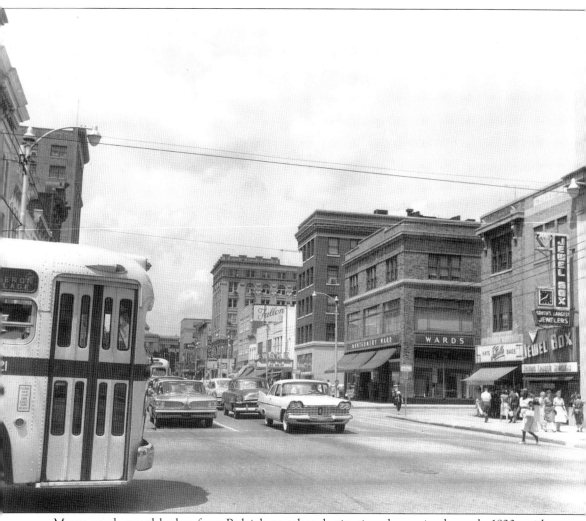

Motor coach travel by bus from Raleigh to other destinations began in the early 1920s with a line to Durham, and national Greyhound bus service to Raleigh commenced in 1933. On September 10, 1941, the new Union Bus Station opened on West Morgan Street to service long-distance bus passengers. The city's first bus transit system began in 1933 after the demise of the electric streetcar system. Here, a Cameron Village-bound bus approaches the intersection of Fayetteville and Martin Streets in downtown Raleigh, c. 1960. (Courtesy Office of Archives and History, Raleigh.)

Four
TOWN AND GOWN

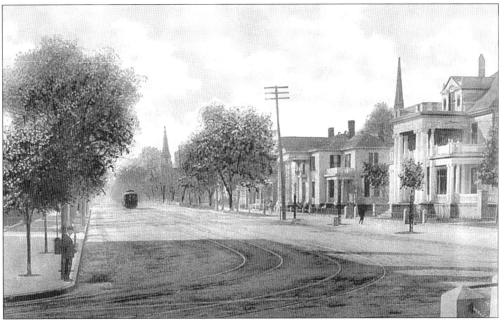

Residential neighborhoods have always been a part of Raleigh. From the earliest neighborhoods located downtown or in the Capitol Square area, to late 19th-and-20th-century suburbs such as Oakwood, Oberlin, and Cameron Park, each residential area had a character of its own, with a unique architectural style and history. The Hillsborough Street neighborhood, seen here in this c. 1910 postcard view looking west from Capitol Square, was the longest continuous neighborhood of 19th-century Raleigh. Architectural styles of the residences in the area just west of the State Capitol included Federal, Greek-Revival, Italianate, and Neoclassical-Revival. This area gradually changed into a commercial thoroughfare, drastically changing the look of the neighborhood. Few of the 19th-century homes remain intact today. (Courtesy Raleigh City Museum.)

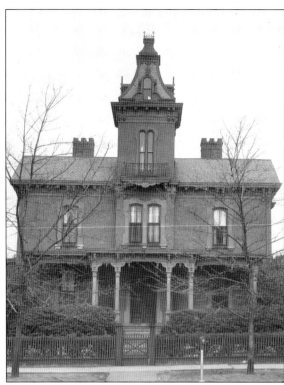

It is believed that the Dodd-Hinsdale House, located at 330 Hillsborough Street, was built c. 1887 by Thomas Briggs for William H. Dodd, who sold it three years later to John Hinsdale. Its High Victorian style was representative of the architecture of the neighborhood. Today, the Dodd-Hinsdale house remains one of the few 19th-century residential structures on Hillsborough Street and is home to the Second Empire Restaurant, named for the building's prominent tower. (Courtesy Office of Archives and History, Raleigh.)

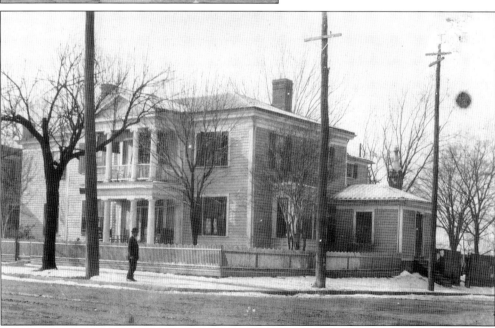

Gov. Daniel G. Fowle maintained his private residence in Raleigh until 1891 when he moved into the newly constructed Executive Mansion. Governor Fowle was the first governor to take up residency in the Executive Mansion which replaced the Governor's Palace, thought to be "ruined" during the occupation of Raleigh by Union troops in 1865. (Courtesy Office of Archives and History, Raleigh.)

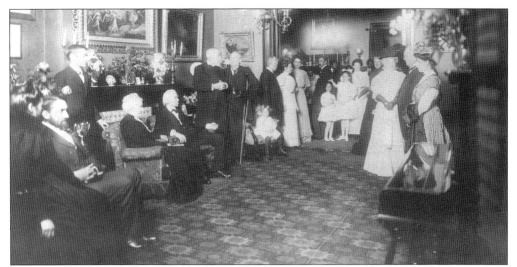

The Blount Street Neighborhood saw the majority of its development from post–Civil War to the 1890s. The area was considered highly desirable with its large Victorian-style homes. This photo from c. 1907 shows the golden wedding anniversary of Dr. and Mrs. Alexander B. Hawkins at their home at 310 North Blount Street. The Hawkins-Hartness house is currently owned by the state of North Carolina. (Courtesy Raleigh City Museum.)

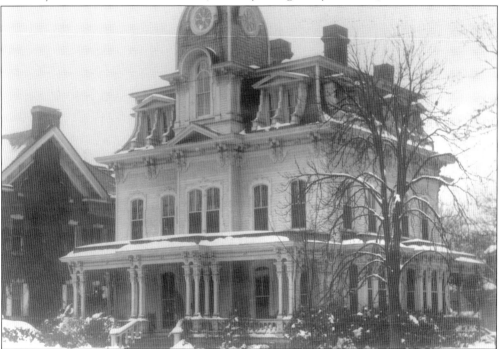

The Heck-Andrews House stands at 309 North Blount Street across the street from the Hawkins-Hartness House. Built in 1869–1870 for Col. Jonathan M. Heck, the house is known for its high mansard roof and tower. Also owned by the state, this building is an example of the few that have survived urban renewal programs, commercial development, and the construction of the state government complex, which led to the removal of many homes in the Blount Street Neighborhood. (Courtesy Office of Archives and History, Raleigh.)

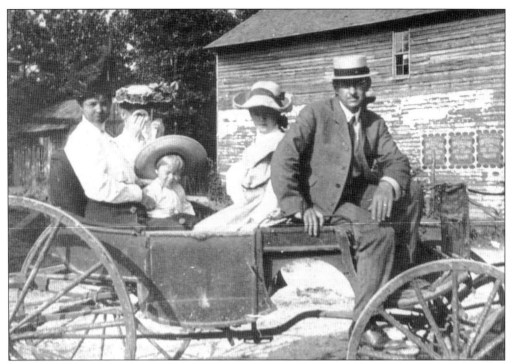

The Bart Gatling family was traveling from their home in the Oakwood Neighborhood to visit friends and family in their buggy in this c. 1910 photograph. (Courtesy Raleigh City Museum/Bill Hutchins.)

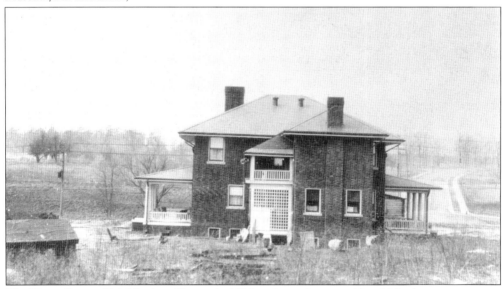

The Hayes-Barton Neighborhood began in 1920 and was then considered "the largest expensive neighborhood of Raleigh." This photograph, taken early in the neighborhood's development, shows the Williamson House, which faced a block of land sold to Josephus Daniels (Secretary of the Navy, 1913–1921). Daniels bought the land at cut-rate prices with the hope that it would encourage others to buy and build there. (Courtesy Raleigh City Museum/Bailey P. Williamson.)

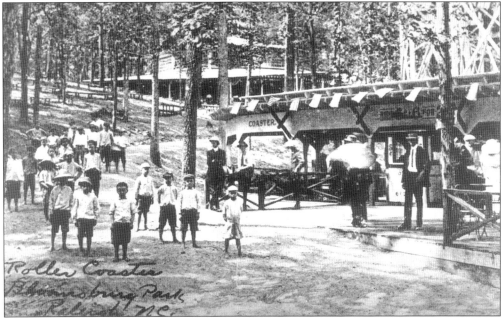

On July 4, 1912, Carolina Power and Light opened Bloomsbury Park northwest of Raleigh, well beyond the existing city limits. The park featured picnic grounds, a penny arcade, a boating pond, a carousel, and a roller coaster. CP&L, owner of the streetcar system, used the park at the end of a streetcar line to encourage ridership. The park was short-lived and by 1920, the amusement grounds were largely abandoned. (Courtesy Office of Archives and History, Raleigh.)

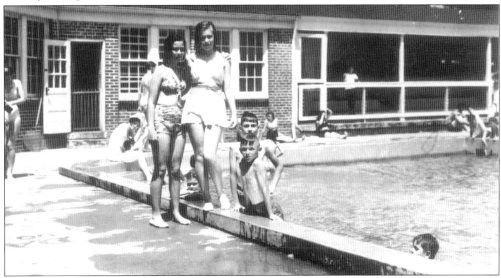

Pullen Park was established in 1887 when Richard Stanhope Pullen donated 64 acres to the City of Raleigh. After Bloomsbury Park closed in the 1920s, the city purchased its c. 1900 Dentzel carousel and moved it to Pullen. Swimming in the Pullen Park Pool, as seen in this 1940s photo, has remained popular for park visitors. Other amenities have included Lake Howell, which hosted ice skating in the winter, a kiddy train, and playgrounds. (Courtesy Office of Archives and History, Raleigh.)

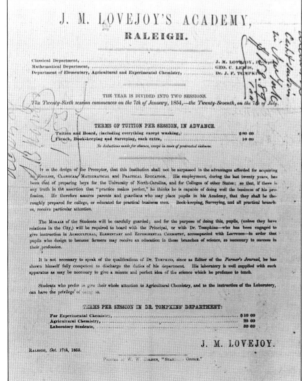

In 19th-century Raleigh, education of children was arranged through private schools and tutors. Raleigh Academy was built in 1804 on Burke Square. Students, who lived at home or boarded with area families, attended classes in reading, writing, needlework, and shorthand. Later, classes in music, drawing, and foreign languages were added. The school buildings were sold in 1830 but were used by other private teachers. (Courtesy Office of Archives and History, Raleigh.)

Jefferson Madison Lovejoy opened his "Classical and English School" in 1842 and moved into the buildings of the former Raleigh Academy in 1843. The school, which became known as Lovejoy's Academy in 1852, educated young men for three decades. An 1854 contract for the Academy is reproduced here. (Courtesy Office of Archives and History, Raleigh.)

Berry O'Kelly was an entrepreneur and perhaps the largest influence on the development of the Method community after the Civil War. In the 1880s, O'Kelly became a partner in the Woods and O'Kelly General Store, located in Method, and established the Method post office in 1890. In 1910, he established his school for African Americans. This portrait of O'Kelly is from a 1919 publication. (Courtesy Office of Archives and History, Raleigh.)

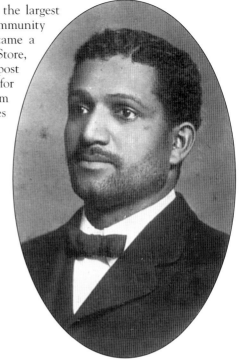

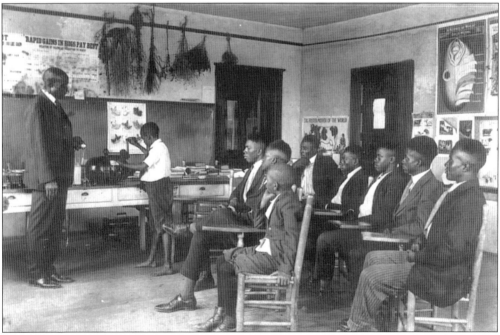

Even into the 20th century, education was not readily available for African Americans. In 1910, however, businessman Berry O'Kelly established a rural high school in the Method community on the outskirts of Raleigh. In 1923, the institution became the first accredited high school for African Americans in North Carolina. (Courtesy Office of Archives and History, Raleigh.)

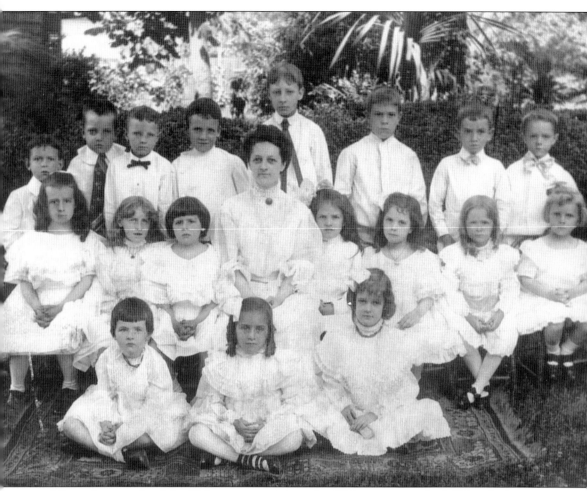

Throughout much of the 19th century and into the 20th century, early childhood education was often left up to small private schools and educators. Miss Lula Busbee taught generations of children in her kindergarten classes, like this class from 1903. Her school was located at the northwest corner of Hargett and Salisbury Streets. Miss Busbee's students from the 1903 class included the following: (first row) unidentified, Fannye McKee Schwartz, and Mildred Briggs; (second row) Grace Crews, ? Myatt, Katherine Crews, teacher Miss Lula Busbee, Mary Frances Bowen, Florence Busbee, Alice Goersch, and Ruth ?; (third row) George Goodwin, Edwin Sewell, unidentified, Sam Telfair, Willie Martin, William Grimes, Joe Martin, and Thomas Wharton. (Courtesy Raleigh City Museum.)

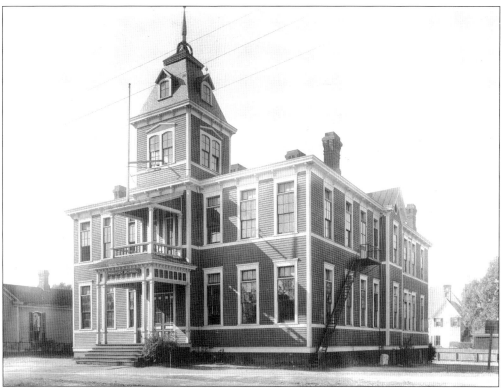

Murphey School, an elementary school on North Person Street, was part of the Raleigh City Schools. The original building, seen here, was destroyed by fire in 1914 but was rebuilt. It was the first school to be desegregated when seven-year-old William Campbell enrolled in 1960; it now serves as housing for the elderly. (Courtesy Office of Archives and History, Raleigh.)

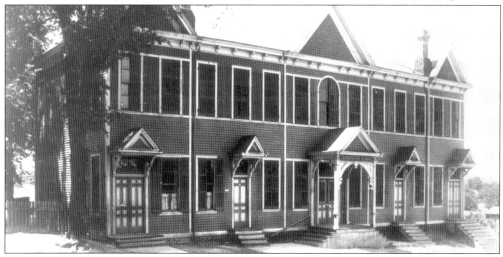

Rev. Fisk P. Brewer established Washington Elementary in 1866 at South and McDowell Streets to teach both white and African-American children and to hold night classes for adults. In 1877, the school was purchased by the city to teach African-American students through grade eight. Washington Elementary, now located at 1000 Fayetteville Street, remains part of the Wake County school system. (Courtesy Office of Archives and History, Raleigh.)

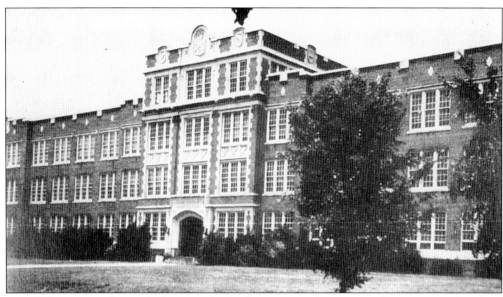

Founded in 1924 and named after one of Raleigh's pioneer educators, Hugh Morson High School served as one of Raleigh's leading public schools for over three decades. The building featured 35 classrooms, an auditorium, gymnasium, cafeteria, and laboratories. In 1955, the school became a junior high. Hugh Morson integrated in 1964, four years after Murphey Elementary was integrated. Two years later, the city tore it down. The Federal Building and Post Office now stand on the former Hugh Morson site. (Raleigh City Museum/B.T. Fowler.)

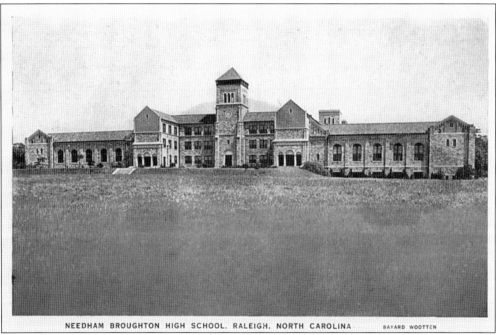

Needham Broughton High School was built on the corner of St. Mary's and Peace Streets in 1929–1930. It was named in honor of a prominent Raleigh businessman and advocate of quality education. The fortress-like building made of native stone remains Raleigh's oldest structure still in use as a high school. (Courtesy Raleigh City Museum.)

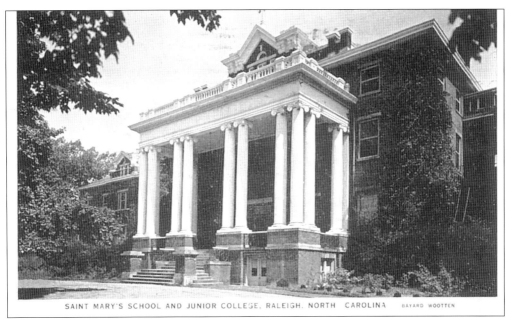

Raleigh has been home to six colleges and universities. The first institute of higher education, St. Mary's School for Girls, as seen in this c. 1939 postcard, was founded in 1842 by Rev. Aldert Smedes on a former school site purchased and donated by Duncan Cameron. It has remained in continuous operation throughout its history. The Episcopal Diocese of North Carolina, who assumed control of the school in 1897, ended the school's tenure as a junior college in the late 1990s, but it remains a private high school. (Courtesy Raleigh City Museum.)

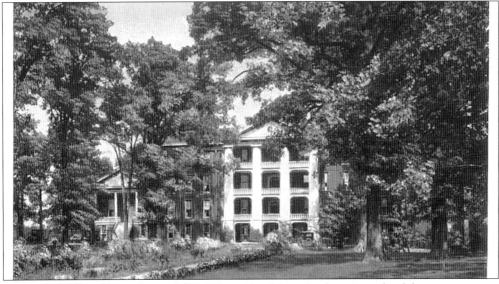

Although William Peace donated $10,000 and land for a Presbyterian school for young women in the 1850s, plans were delayed. In 1861, confederate troops set up a hospital in the unfinished building. After the war, the building was used for the Freedmen's Bureau. Finally, in 1872, the Raleigh Female Institute held its first classes; a year later the school was renamed Peace College. In the late 1990s, the junior college became a four-year institution. (Courtesy Raleigh City Museum.)

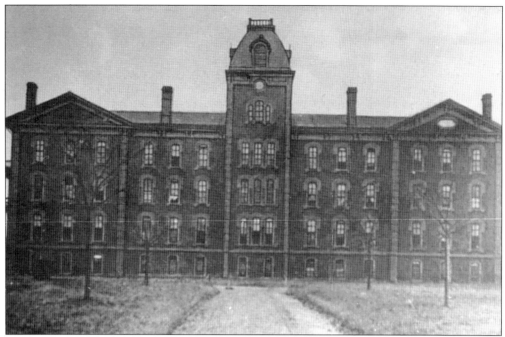

Shaw University, established in 1865, is the oldest historically black college in the South. In 1871–1872, students and faculty built Shaw Hall, the university's first building. Shaw Hall housed classrooms and a library as well as lodging for male students. In 1944, Shaw Hall became a women's dormitory. However, by 1967, the structure had so deteriorated that the school had to raze the building. (Courtesy Raleigh City Museum/B.T. Fowler.)

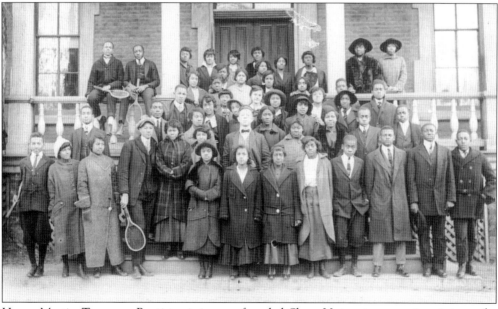

Henry Martin Tupper, a Baptist missionary, founded Shaw University to train ministers for African-American churches. It soon expanded upon this original mission, admitting female students by the late 1860s and adding a medical school in 1881. A c. 1910s graduating class posed for this photograph. (Courtesy Office of Archives and History, Raleigh.)

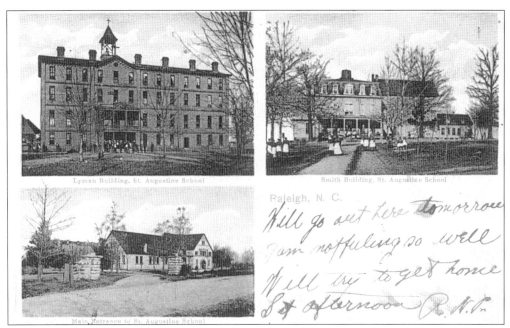

In 1867, St. Augustine's Normal and Collegiate Institute was founded by the Episcopal Church and its Freedmen's Commission. The school, seen in this c. 1908 postcard, became a junior college in 1923, was renamed St. Augustine's College in 1928, and became an accredited four-year institution in 1934. (Courtesy Raleigh City Museum.)

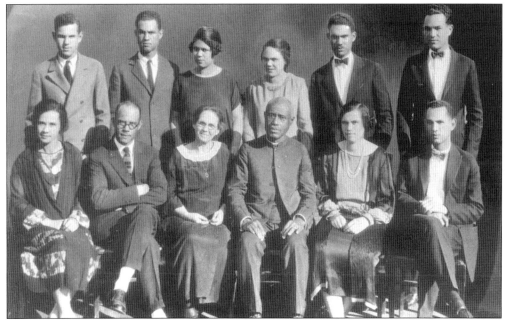

In the early 20th century, Bishop Henry Delany served as vice principal of St. Augustine's College and his wife, Nanny James Logan Delany, was the matron. The Delany family posed for this 1920s photograph. Shown left to right are (front row) Bessie, Lemuel, Mrs. Delany, Bishop Delany, Sadie, and Harry (Hap); (back row) Sam, Hubert, Laura, Julia, Lucius, and Manross. (Courtesy Raleigh City Museum/Nan Delany Johnson.)

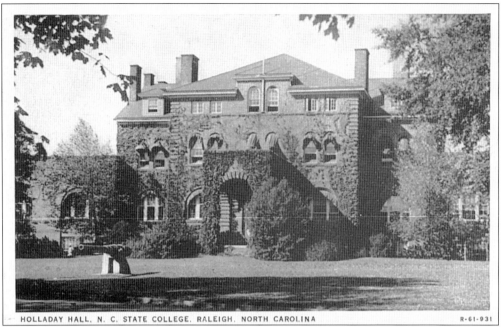

In 1889, the North Carolina College of Agriculture and Mechanical Arts opened its doors in the western part of the city. A land-grant college, NC A&M, later renamed North Carolina State University, specialized in agricultural and industrial studies in its early years. Holladay Hall was the first building on campus. (Courtesy Raleigh City Museum.)

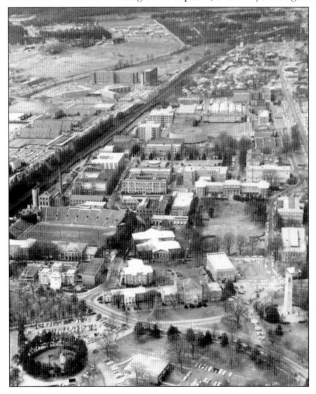

North Carolina State University's campus has grown tremendously. This 1968 photograph of central campus includes the round Harrelson Hall, built a few years before the photograph. Harrelson's unique design continues to make it a landmark today. (Courtesy Office of Archives and History, Raleigh.)

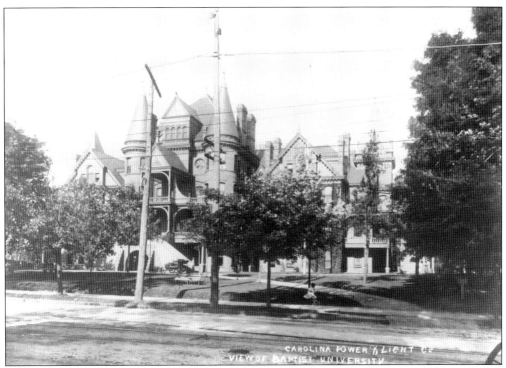

In 1899, Baptist Female University opened its doors at the corner of Edenton and Blount Streets. In 1905, the school was renamed Baptist University for Women and in 1909, the school became Meredith College. Needing more space, Meredith College moved to its present location in west Raleigh in 1926. The former site became a hotel and later state offices. It was demolished in 1967. (Courtesy Office of Archives and History, Raleigh.)

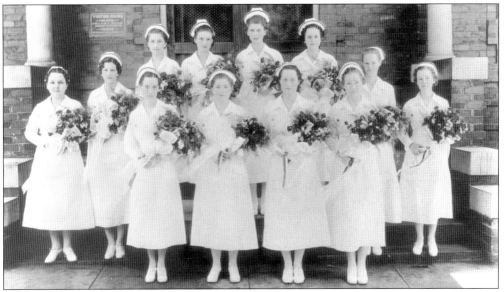

Nursing was one of the few professions open to women in the early 20th century. A training center for nurses was established in Rex Hospital. The photograph shows the class of 1936 of the Rex Hospital School of Nursing. (Courtesy Raleigh City Museum/Mabel Dillard.)

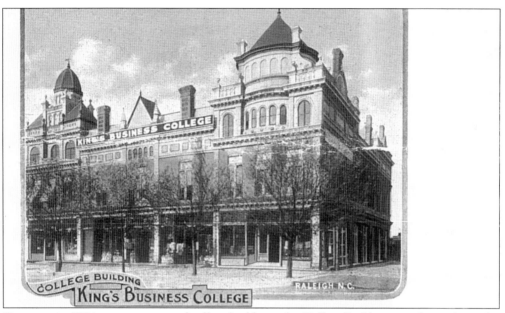

Opening in 1894 as a commercial office building, the Pullen Building was located on the northwest corner of Fayetteville and Davie Streets just south of the Wake County Courthouse. Its primary tenant during the early 20th century was the King's Business College. King's was founded in 1901 and offered classes including typing, shorthand, secretarial, and banking. (Courtesy Office of Archives and History, Raleigh.)

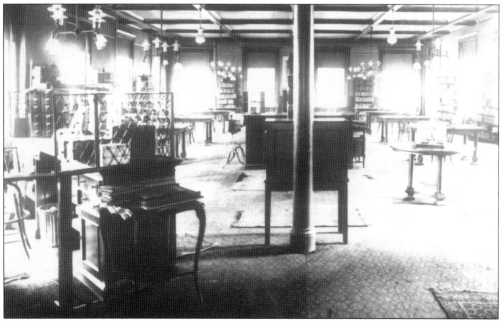

In 1899, Richard Beverly Raney donated the Olivia Raney Library to the city as a memorial to his late wife. The library, which opened on the corner of Hillsborough and Salisbury Streets in 1901, was Raleigh's first public library. Needing to expand, the library sold its original building to the state and moved to a new location on Fayetteville Street in the early 1960s. The state demolished the original building in 1965. (Courtesy Office of Archives and History, Raleigh.)

Five

NATIONAL EVENTS AND THE LOCAL EXPERIENCE

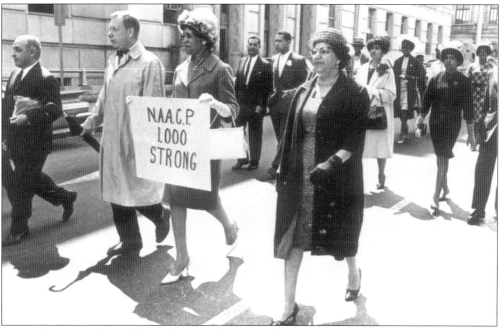

National events affected Raleigh as much as any other city in the country. In the 1950s and 1960s, the existing social system based on Jim Crow laws was challenged by members of the community. Some church leaders encouraged congregations to rethink their understanding of human rights. In some cases, members of African-American and white congregations stood together in a call for widespread social change. Students banded together to protest inequality. Other organizations also stood up and voiced concerns. The National Association for the Advancement for Colored People (NAACP) played a pivotal role in providing a support network for African Americans. Marches became common sights on Raleigh streets in the early 1960s. Here, members of the NAACP and supporters of civil rights march downtown on April 15, 1963. (Courtesy Office of Archives and History, Raleigh.)

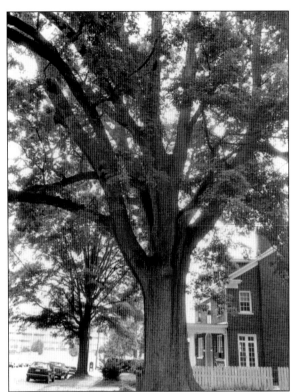

According to legend, in 1844, presidential candidate Henry Clay sat under this tree at North and Blount Streets and wrote in his "Raleigh Letter" that annexing Texas without Mexico's consent would result in war. Stating, "I would rather be right than be president," Clay ultimately lost the election and the United States went to war with Mexico. The Henry Clay Oak was removed in 1991 because of disease. (Courtesy Office of Archives and History, Raleigh.)

Raleigh's city flag was created in 1899 as a gift for the USS *Raleigh* and her crew. This cruiser was very influential in the Battle of Manila Bay, Philippines Islands during the Spanish-American War. During the battle, the USS *Raleigh* took a small cannon from a Spanish warship and arranged to present it to the City of Raleigh. (Courtesy Office of Archives and History, Raleigh.)

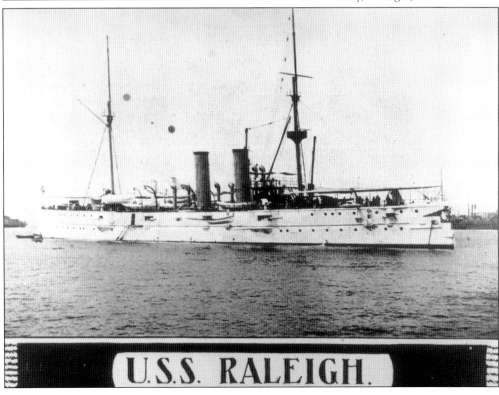

The Raleigh Board of Alderman (later City Council) believed that a reciprocal gift was needed to thank the USS *Raleigh* for their gift of a cannon. They contracted Kate Denson, seen here c. 1905, to create a city flag for a fee of $50. Completed in October 1899, the flag was officially presented to the Board of Alderman for approval on December 1, 1899. (Courtesy Raleigh City Museum/ Beverly Webb.)

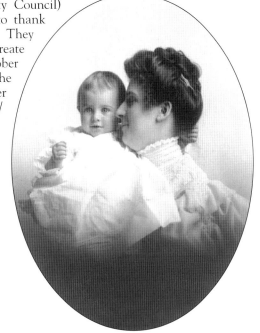

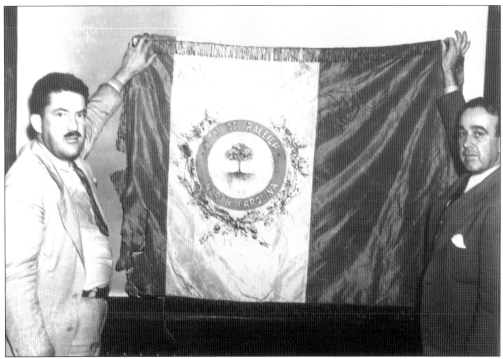

In 1960, the original Raleigh flag was rediscovered after a long public absence. By this time, most residents were not aware that Raleigh even had a flag. The flag was uncovered in the old City Hall during the move to the new Municipal Building. Found in a severely deteriorated condition, the flag was eventually conserved, replicated, and adopted as the "authentic flag of the city." (Courtesy Office of Archives and History, Raleigh.)

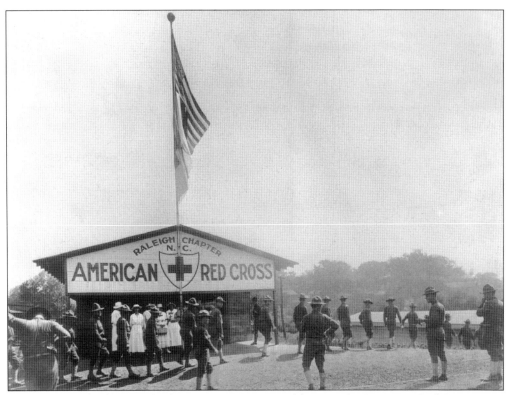

Raleigh has a long history of volunteerism. During World War I, the American Red Cross set up a facility in Raleigh, seen here in this c. 1917 photograph, allowing citizens to help with the war effort. (Courtesy Office of Archives and History, Raleigh.)

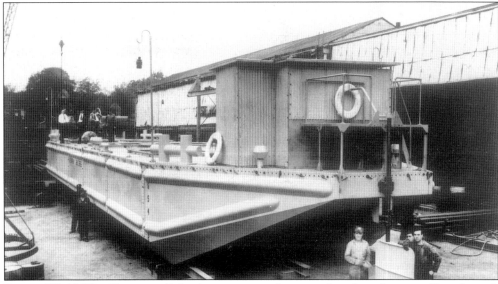

During World War II, private Raleigh companies also contributed to the war effort through industrial production. Peden Steel Company produced 48 steel barges, like the one pictured here, for the United States Armed Forces and received the Army-Navy "E" pennant for superior wartime production in 1944. (Courtesy Raleigh City Museum/James Peden Jr.)

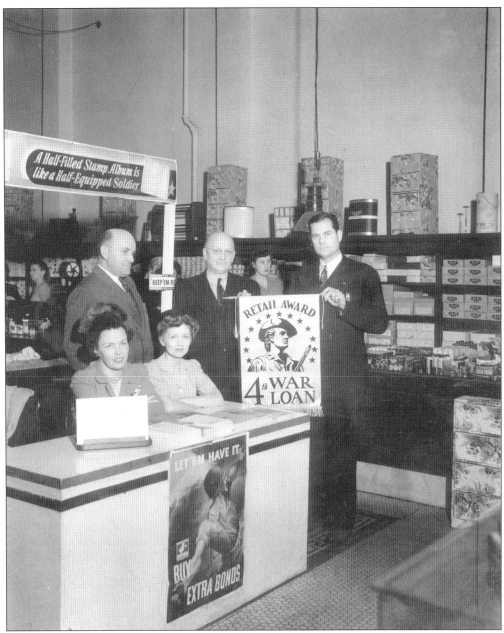

During World War II, the war effort in Raleigh extended to scrap drives, tire collections, and planting personal or neighborhood victory gardens. Food and gasoline were rationed and citizens in Raleigh, like their fellow citizens across the nation, used their ration books and stamps in order to get their share of supplies. A neighborhood watch was established for local security and volunteers spent time looking at the sky to identify any enemy airplanes. Air raid sirens were set up and Raleighites practiced blackout procedures. Stars appeared in windows where families had men fighting in Europe or Asia. The call to buy war bonds to fund the national campaign was universal. Retailers, like the Boylan Pearce Department Store seen here, mounted posters and set up booths to encourage citizens to buy war bonds as a way to contribute to the war effort. (Courtesy Office of Archives and History, Raleigh.)

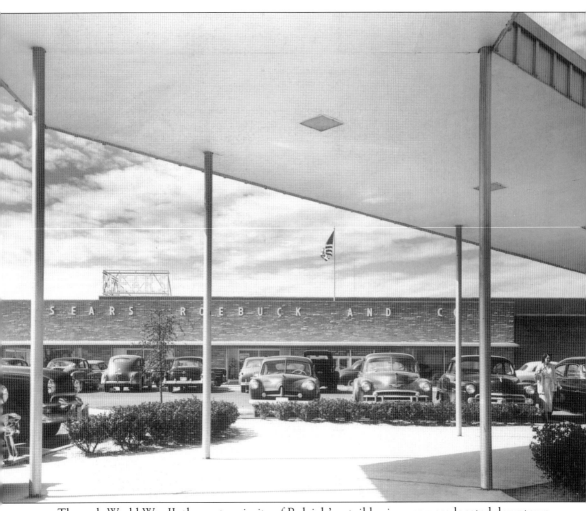

Through World War II, the vast majority of Raleigh's retail businesses were located downtown. When Cameron Village opened in 1949, it created a shopping revolution and radically altered the retail community. Soon, a suburban exodus shifted the concentration of shopping away from Raleigh's traditional main street to the ease and convenience of the modern shopping center. The project began in 1947, when J.W. York and his partner, R.A. Bryan, purchased 158 undeveloped acres of the old Cameron estate west of St. Mary's School. The idea was to build a landscaped development of shopping, services, apartments, and single-family homes. The open-air shopping mall, designed by Leif Valand, was Raleigh's first retail district away from downtown and was considered the first major center between Washington and Atlanta. By the end of its first year, the "town within a town" at Cameron Village had 65 stores, 112 business/professional offices, 566 apartment units, and 100 private homes. Cameron Village soon attracted national stores like Sears Roebuck and quickly gained the reputation as *the* place to shop. (Courtesy Raleigh City Museum.)

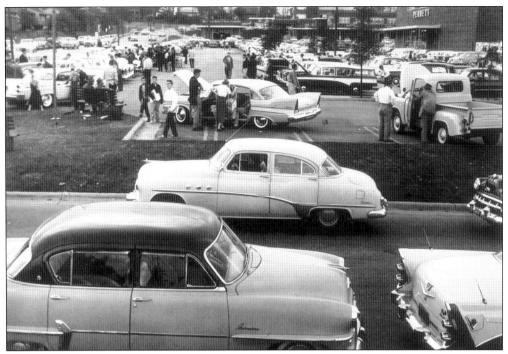

Cameron Village's attractive setting and ample parking enticed customers and retailers. The shopping center became a popular destination for more than just shopping, dining, or conducting business. In this 1957 photograph, a new auto show was held in the shopping center's parking lot. (Courtesy Raleigh City Museum.)

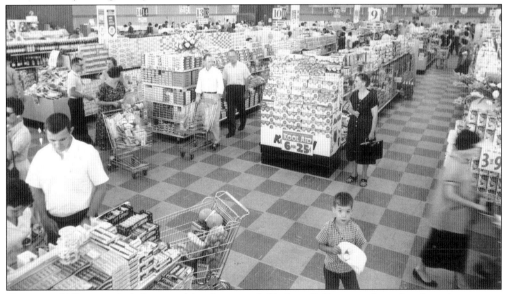

Cameron Village included stores like Sears and Hudson-Belk to anchor the shopping center and provide large department stores as a major destination. Colonial Stores, a supermarket, also provided a prime retail stop for the residents who lived in the newly developed Cameron Village neighborhood and nearby established neighborhoods like Cameron Park. (Courtesy Raleigh City Museum.)

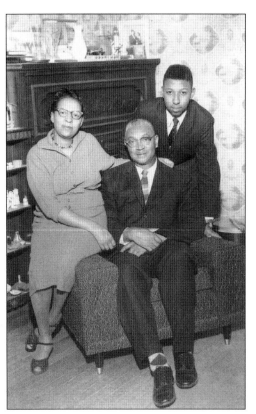

In the years after the 1954 Supreme Court decision, which ruled that segregated schools were unconstitutional, African-American families waited anxiously for the decision to take effect locally. In August 1956, Joseph and Elwyna Holt initiated an attempt to enroll their son, Joe, in an all-white school in his neighborhood. This was the first attempt in Raleigh to desegregate local schools. (Courtesy Raleigh City Museum/Joseph H. Holt Jr.)

In 1960, Raleigh students staged lunch counter sit-ins. Almost immediately, these stores responded with signs bearing such messages as "Closed in the Interest of Public Safety" and denied all meal service to both black and white patrons. In this photograph, student protestors conduct a sit-in at the Woolworth's lunch counter to protest its whites-only service in March 1960. The lunch counters were eventually desegregated by 1964. (Courtesy Office of Archives and History, Raleigh.)

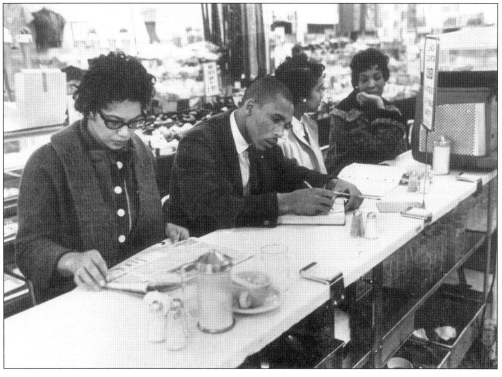

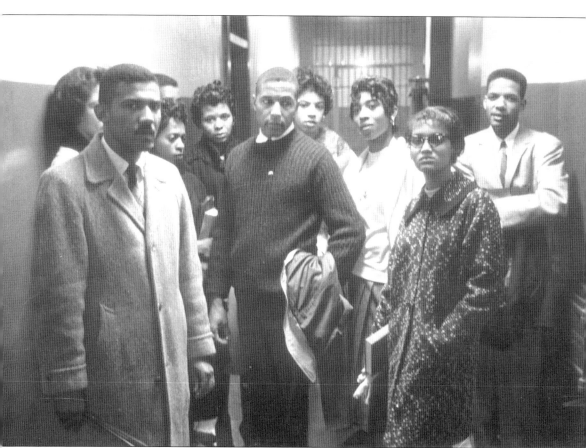

Although student protests in Raleigh were based on the non-violent approach espoused by Martin Luther King Jr., the students were always aware that tremendous risks were involved. Not only were protestors vulnerable to reactions by the white community, but legal ramifications were always a possibility. Some students, like those seen here with Attorney George R. Greene in February 1960, were arrested for trespassing. Charges were later dropped because of a 1946 Supreme Court decision stating that sidewalks, even on private property, were open to the public. Attorney Greene was a member of the Taylor and Mitchell Law Firm, which had a reputation as a law firm dedicated to supporting civil rights. Founding their law firm in 1952, Herman L. Taylor and Samuel S. Mitchell became a formidable team known across the state for their efforts in civil rights cases. One of their first local cases was working for the Holt family in their suit against the Raleigh City School Board. (Courtesy Office of Archives and History, Raleigh.)

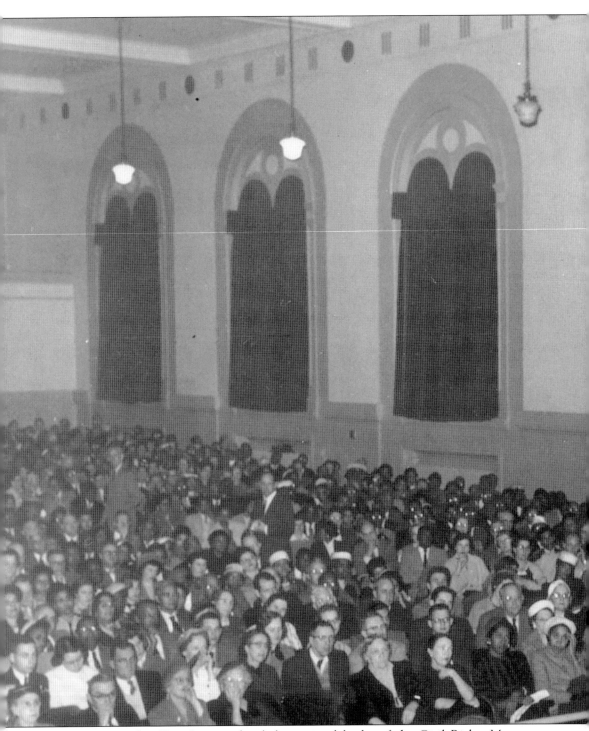

Dr. Martin Luther King Jr., considered the national leader of the Civil Rights Movement, influenced the local movement as well. King encouraged students and adults to use a non-violent approach as a means to protest, thus creating a national and local phenomenon of marches and sit-ins. King brought his message to Raleigh and its civil rights activists several

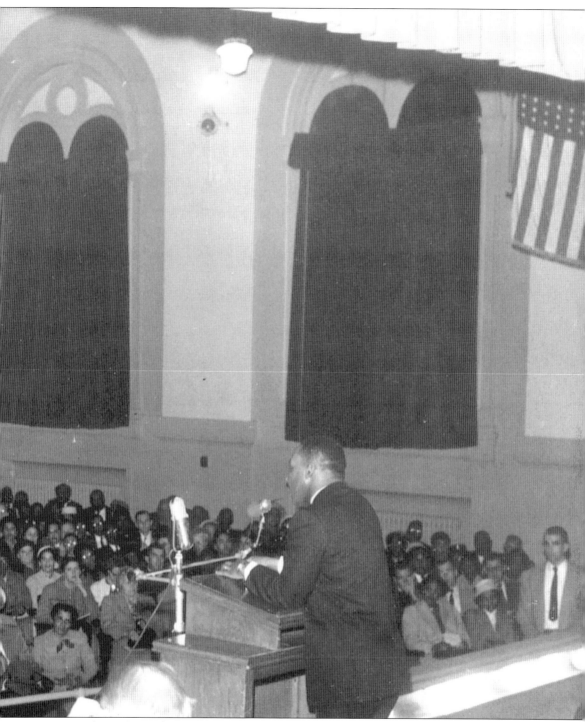
times in the 1950s and 1960s. On February 10, 1958, Martin Luther King Jr. addressed an audience assembled for the Institute of Religion lecture series in the auditorium of Needham Broughton High School. (Courtesy Office of Archives and History, Raleigh.)

Natural disasters have also had a local impact in Raleigh. While Raleigh is located well inland, the occasional powerful hurricane along North Carolina's coast can still wreak havoc by the time it arrives. In 1954, Hurricane Hazel's 90-mph winds felled trees and telephone poles throughout Raleigh, leaving 85 percent of the city's homes without power for days. On the night of September 5, 1996, the worst natural disaster in Raleigh's history hit when Hurricane Fran stormed through the area. By the morning of September 6, residents began inspecting the damage and found trees smashed on top of houses and cars, roads blocked, and telephone and electrical power nonexistent for days. This photograph shows the damage inflicted by Fran on a home in the Hayes-Barton neighborhood. (Courtesy Raleigh City Museum/Sally Adams.)

Six

CELEBRATING A CAPITAL CITY

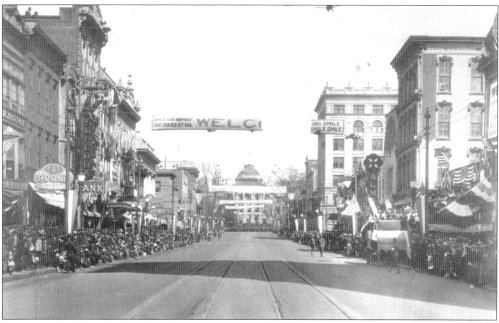

As North Carolina's capital city, Raleigh has hosted a multitude of state and civic celebrations since its founding in 1792. From the North Carolina State Fair and gubernatorial inaugurations to parades, festivals, and museums, Raleigh prides itself on entertaining North Carolinians from all walks of life. As a political center, it has also experienced the local impact from national issues. Here, Raleigh citizens display their patriotism by holding a parade on Fayetteville Street for North Carolina's returning World War I soldiers in 1919. The torn banner over the street quoted a popular song of the day, "Unpack your trophies from your old kit bag and SMILE, SMILE, SMILE!" (Courtesy Office of Archives and History, Raleigh.)

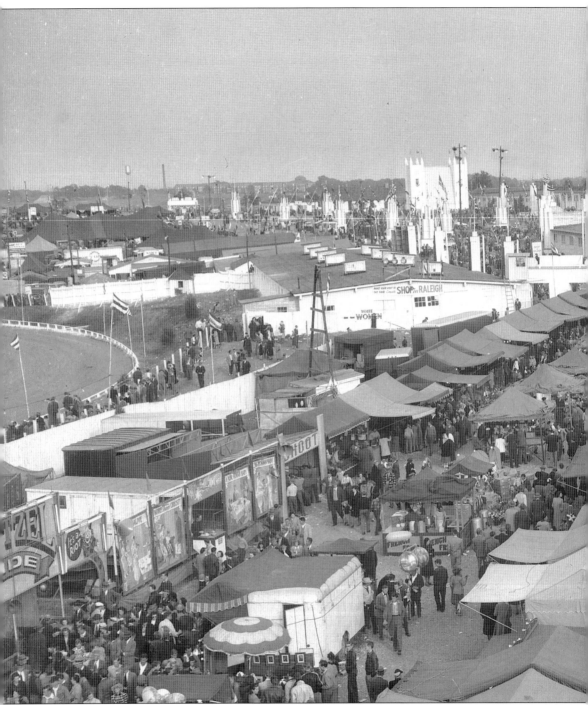

No single annual event brings more North Carolinians to Raleigh than the North Carolina State Fair. Started as an agricultural exposition in 1853, the first fair was held at an 8.5-acre site east of downtown between Hargett and Davie Streets. During the Civil War, it was briefly discontinued and the fairgrounds were used for Confederate troop encampments. The celebration resumed in 1869, and in 1873, the fair moved to a larger site west of downtown and

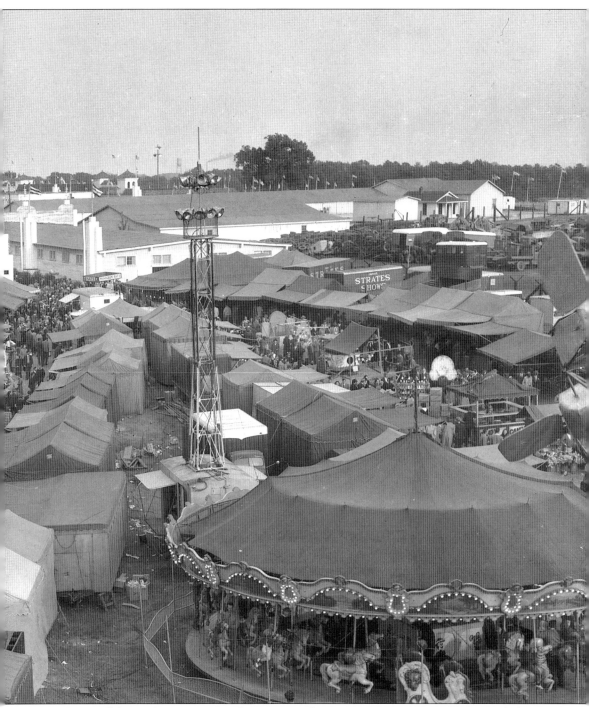

north of Hillsborough Street across from present-day NC State University. It remained there until 1929 when it moved further west to the present-day fairgrounds located at the intersection of Hillsborough Street and Blue Ridge Road. This aerial perspective from the 1948 State Fair shows a midway full of vendors, amusement rides, and visitors. (Courtesy Office of Archives and History, Raleigh.)

In addition to agriculture and livestock offerings, the State Fair also provides a venue for North Carolina's various communities to display their local products and express pride in their locale. This exhibit, from the 1884 State Fair, advertises the advantages of life in Chatham County, North Carolina. (Courtesy Office of Archives and History, Raleigh.)

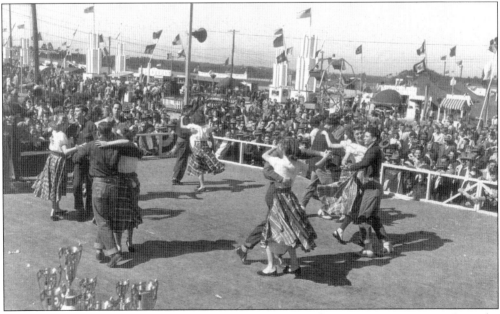

Other major attractions at the State Fair are the music and entertainment venues. Over the years, the fair has hosted national performing acts as well as providing opportunities for local talent. Here, dancers demonstrate the latest moves for prize money and trophies in an early 1950s State Fair. (Courtesy Office of Archives and History, Raleigh.)

Early state fairs were sponsored by the North Carolina State Agricultural Society, formed in Raleigh in 1852. At that time, North Carolina was primarily an agricultural state. Today, agriculture-related displays and activities remain an important staple at the fair. Here, a family reviews an exhibit describing how tobacco is cultivated at the 1946 State Fair. (Courtesy Office of Archives and History, Raleigh.)

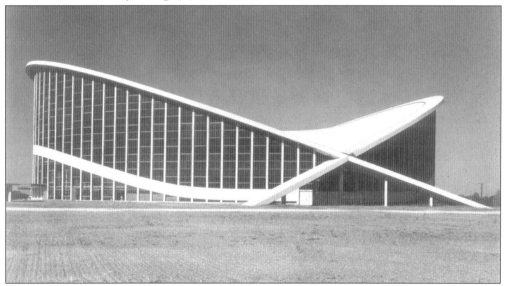

Named for former State Fair manager J.S. Dorton, the Dorton Arena opened in 1952 on the fairgrounds. Used primarily as a pavilion for livestock judging, the arena was designed by architect Matthew Nowicki in a unique parabolic plan that employs suspension cables to support the structure. Over the years, Dorton Arena hosted concerts, ice hockey games, and other community events. (Courtesy Office of Archives and History, Raleigh.)

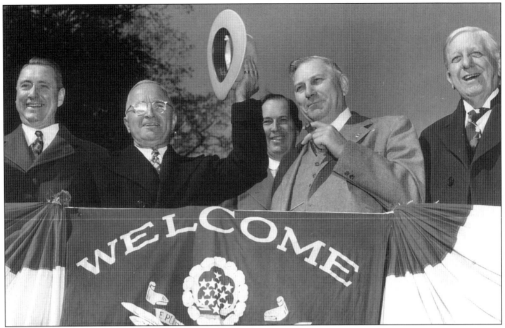

Raleigh has been visited by several former and current presidents. Harry S Truman came to town in October 1948 to attend ceremonies for the unveiling of the *Three Presidents* monument on Union Square. Seen here, from left to right, are Willis Smith, President Truman, Kenneth Royal Sr., Gov. R. Gregg Cherry, and Sen. Clyde R. Hoey. (Courtesy Office of Archives and History, Raleigh.)

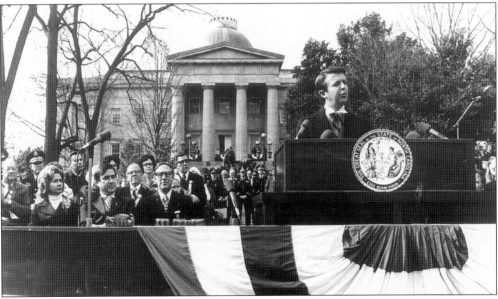

Dating as far back as the late 18th century, Raleigh has welcomed new governors and their administrations to the capital city. Usually a formal affair, gubernatorial inaugurations were typically held on the grounds of the State Capitol and followed by a parade through town. In this photograph, Gov. James E. Holshouser Jr. addresses the audience at his January 1973 inauguration. (Courtesy Office of Archives and History, Raleigh.)

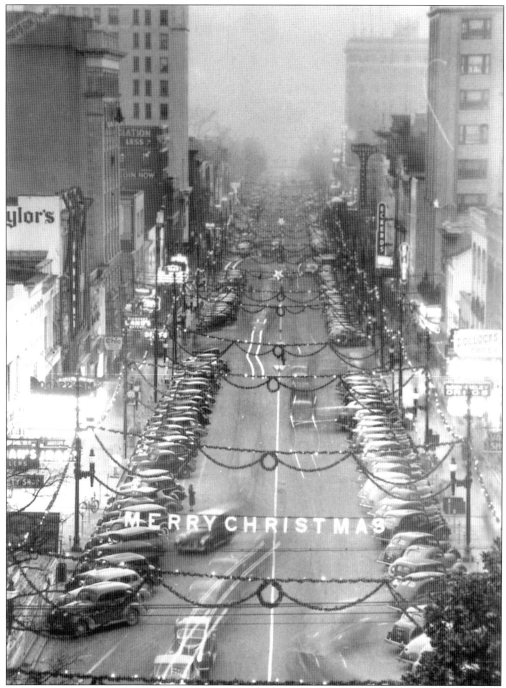

Holidays also offer a chance for civic celebration in Raleigh, a tradition that began with the original 1794 statehouse as an early focal point. As the major commercial thoroughfare, Fayetteville Street, seen here c. 1940, was adorned with decorations and lights during the Christmas season. Starting in 1940, the street also hosted the annual Merchants Bureau Christmas Parade, which marked the beginning of the traditional holiday shopping season along its retail corridor. (Courtesy Raleigh City Museum/Lucille Harris.)

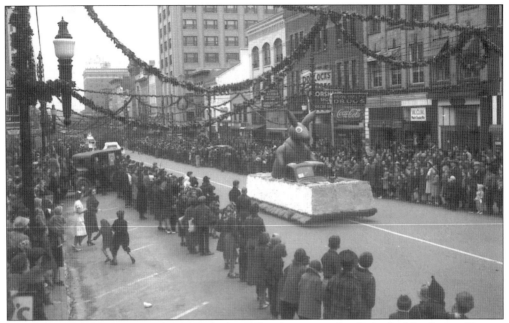

Usually held in late November, just before Thanksgiving, the Raleigh Merchants Bureau Christmas Parade drew large crowds to a festively decorated Fayetteville Street. Here, c. 1940, lines of onlookers crowded along the street's 100 block to catch a glimpse of the parade. (Courtesy Office of Archives and History, Raleigh.)

Each year, children of all ages lined the streets of downtown to watch the floats and marching bands in the Christmas Parade. Santa Claus was found sitting atop a float at some point along the parade route, and giant balloons intrigued young and old. Seen here, two young children intently watch the 1953 Raleigh Christmas Parade. (Courtesy Office of Archives and History, Raleigh.)

Holiday preparation has long been a fun activity for many Raleigh families. Here, tree shoppers carefully inspect holiday greenery during the 1938 season at this Christmas tree vendor's stand located across from Hugh Morson High School. (Courtesy Office of Archives and History, Raleigh.)

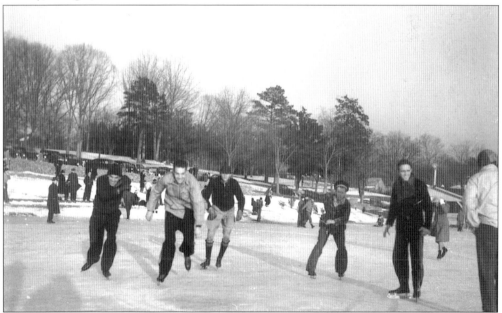
Although Raleigh's climate is relatively mild during the winter months, it still affords residents a chance to enjoy activities unique to this time of year. This c. 1940 photograph shows a group of ice skaters enjoying a cold January afternoon skating on frozen Lake Howell at Pullen Park. (Courtesy Office of Archives and History, Raleigh.)

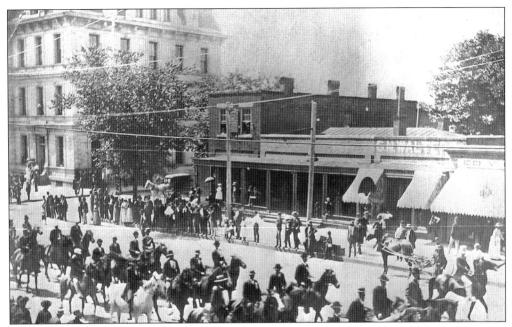

Parades to celebrate Independence Day, returning war veterans, or the visiting circus were also frequent happenings downtown. With the first three blocks south from the State Capitol housing hundreds of businesses, Fayetteville Street was designed to run 99 feet across and could easily accommodate several lanes of traffic. This 1892 photograph documents the Raleigh Centennial Parade moving north on the 200 block. (Courtesy Office of Archives and History, Raleigh.)

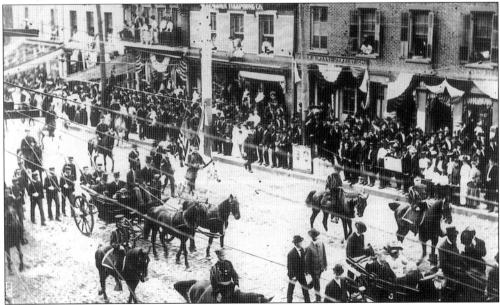

A highlight of any parade was the chance to see visiting dignitaries riding along its route. This 1905 parade shown along Fayetteville Street's 100 block included United States president Theodore Roosevelt riding in the carriage seen in the lower right-hand corner of the photograph. (Courtesy Office of Archives and History, Raleigh.)

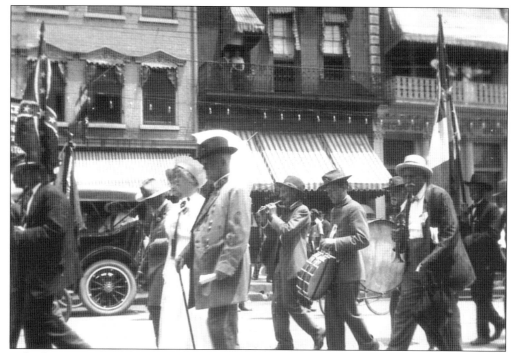

Raleigh continued to honor its Civil War heroes well into the 20th century. Denmark Photography captured this Confederate Veterans Parade moving through downtown in 1915. L.P. Denmark and his brother, James, were photographers in Raleigh in the early 20th century. (Courtesy Raleigh City Museum/Jay Denmark)

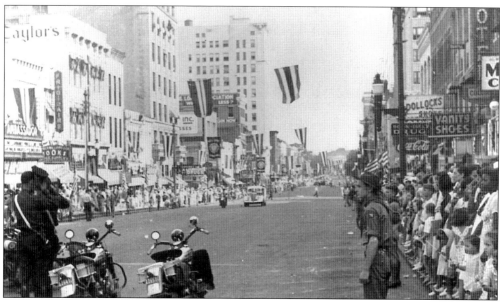

In August 1939, Raleigh's residents lined Fayetteville Street for the American Legion Parade. (Courtesy Office of Archives and History, Raleigh.)

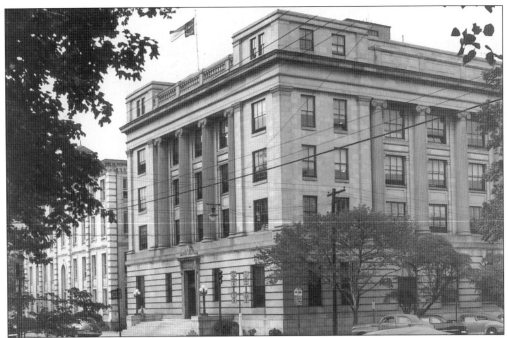

Much of downtown Raleigh is dedicated to state government offices. The 1922 Agriculture Building, depicted here, was erected on the Edenton Street site of the former Eagle Hotel. The hotel had been purchased by the State of North Carolina in 1881 and converted into the State Department of Agriculture before being removed 40 years later for this enlarged facility. (Courtesy Office of Archives and History, Raleigh.)

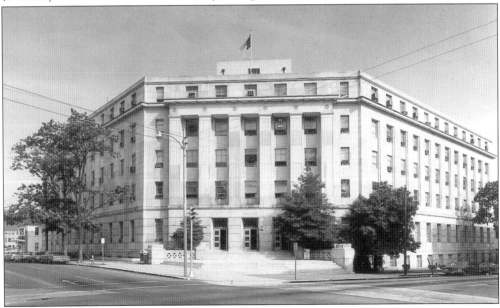

The State Board of Education dates back to the 1860s when North Carolina's new constitution dictated tax-supported public schools. The Education Building, located at the corner of Edenton and Salisbury Streets, was built in phases from 1938 to 1947. (Courtesy Office of Archives and History, Raleigh.)

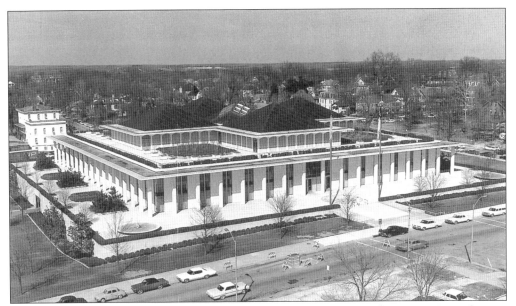

For more than 120 years, the General Assembly met in the 1840 statehouse on Union Square. By the 1950s, the need for more space for the legislature was apparent, and a new facility was planned. Opening in 1963 between Lane and Jones Streets, the North Carolina State Legislative Building was designed in the modern "International" style by architect Edward Durell Stone. (Courtesy Office of Archives and History, Raleigh.)

The North Carolina Office of Archives and History and the State Library of North Carolina are located in this facility, which was constructed on Jones Street in the 1960s. The archives hold the official records for the state as well as a large collection of photographs, literature, motion pictures, and other reference materials and media related to North Carolina. (Courtesy Office of Archives and History, Raleigh.)

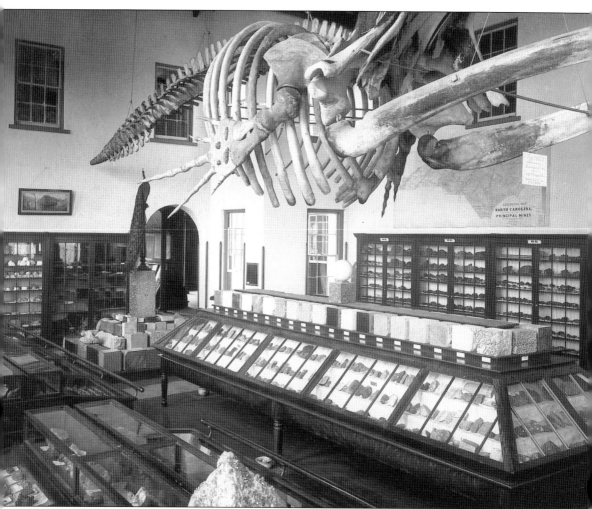

Founded in 1879 by the General Assembly, the State Museum of Natural History exhibited artifacts related to North Carolina's natural resources. The first curator of the museum, H.H. Brimley, is credited with dramatically increasing the museum's collection of animal skins and mounted displays. Now known as the North Carolina State Museum of Natural Sciences, the museum is housed in a state-of-the-art facility that opened in 2000. This photograph depicts the lobby of the old museum in the early 20th century when it was located in the Agriculture Annex. (Courtesy Office of Archives and History, Raleigh.)

The outbuilding believed to be the birthplace of President Andrew Johnson has stood at several locations in Raleigh. Originally located behind Casso's Tavern at Fayetteville and Morgan Streets, the structure has also been located on several sites including Pullen Park. In the 1970s, it was moved to Mordecai Historic Park. This photograph shows the movers proceeding past the State Capitol with the house. (Courtesy Office of Archives and History, Raleigh.)

Originally housed in the Borden Building in Fred Fletcher Park, the Raleigh City Museum opened in 1993 through the efforts of community activists interested in preserving city artifacts from the past. A private non-profit organization, the museum moved to its current location in the historic 1874 Briggs Building in late 1998. Seen here, the museum's entrance includes a 17th-century wooden statue of Sir Walter Raleigh. (Courtesy Raleigh City Museum.)

The Raleigh Little Theatre was dedicated in 1940 on the former site of the State Fairgrounds north of Hillsborough Street. A venue for amateur productions, the theater's grounds include an expansive rose garden. A new teaching theatre was added to the original structure in the 1980s. This aerial perspective was taken in 1949. (Courtesy Office of Archives and History, Raleigh.)

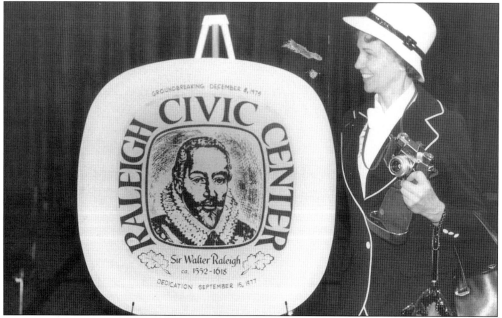

Civic leaders began to debate ways to revitalize downtown Raleigh in the 1960s and 1970s as many retail businesses moved to new locations in the growing suburbs. One realized project was the Raleigh Civic Center, dedicated in September 1977 and constructed at the end of Fayetteville Street north of Memorial Auditorium. Shown here, local historian Elizabeth Reid Murray spoke at its dedication ceremony. (Courtesy Raleigh City Museum/Calvin R. Parks Jr.)

Opening in 1932, Memorial Auditorium remains Raleigh's most significant performing arts facility. Capable of seating over 2,000, the auditorium is home to the North Carolina Symphony and the North Carolina Theatre. It underwent renovation in the 1980s that included the extension of its lobby and Doric columns. The complex received an even greater reconstruction in the late 1990s when new performance hall wings were added and it was renamed the BTI Center for the Performing Arts. (Courtesy Raleigh City Museum/Calvin R. Parks Jr.)

One of the earliest Raleigh business organizations was the Raleigh Chamber of Industry, formed in 1888. This organization evolved into the Greater Raleigh Chamber of Commerce, which has involved itself with civic causes such as the construction of Falls Lake and the merger of the city and county school systems. This photograph from the 1960s shows a chamber group leaving on a bus trip. (Courtesy Greater Raleigh Chamber of Commerce.)

Cap. J.E. Hamlin started the Hamlin Drug Co. on East Hargett Street in 1915. At that time, the pharmacy was an integral part of the African-American business district. Purchased from the Hamlin family in the 1950s by pharmacists Clarence C. Coleman and John M. Johnson, Hamlin Drugs continues today as an independently-owned business succeeding in a world of national chain stores. (Courtesy Raleigh City Museum.)

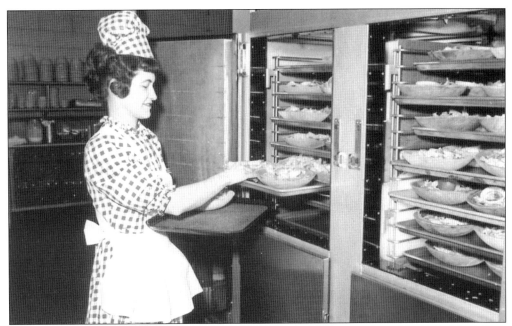

Best-known for its steak, the Angus Barn first opened its doors on June 28, 1960. Thad Eure Jr.—known as the "original barnmaster"—and Charles Winston were inspired by Eure's father to buy land for a restaurant on US 70 near the new Research Triangle Park. Here, a waitress retrieves salads from the restaurant kitchen, c. 1960s. (Courtesy Raleigh City Museum/Van Eure of the Angus Barn.)

In 1984, Nancy Olson and her husband, Jim, opened a store to fill the need for an independent bookseller in Raleigh. Now called Quail Ridge Books, the bookstore has nurtured relationships with both national and local authors. Pictured from left to right at a 1990s book signing are (front row) authors Amy Tan and Kaye Gibbons; (back row) owner Nancy Olson and an unidentified customer. (Courtesy Raleigh City Museum/Nancy Olson.)

While downtown Raleigh experienced a wave of revitalization, the economic benefits of the 1990s spread to other areas of the city and invigorated established districts. City Market, located south of Moore Square, experienced such a renewal. The Market building was erected in 1914 to house the local farmer's market. While the complex initially prospered, the advent of the supermarket eventually brought about its closure in the 1950s. (Courtesy Raleigh City Museum.)

By the 1980s, City Market was reinvented as an adaptive re-use project designed for art galleries, gift shops, and restaurants. The area around City Market has also seen a rebirth and now hosts annual arts festivals and monthly gallery walks. (Courtesy Raleigh City Museum.)

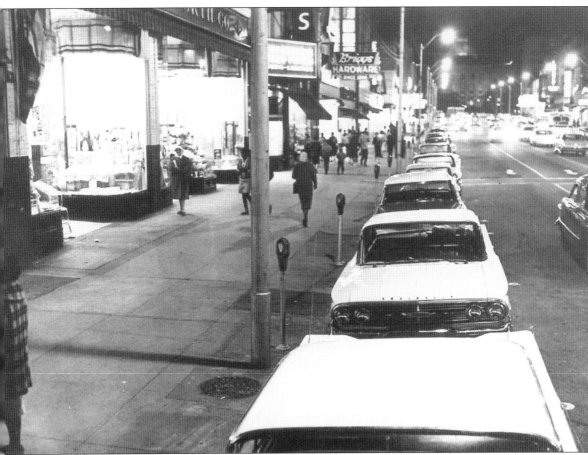

The advent of suburban shopping malls and housing complexes drew people away from downtown Raleigh as the city's boundaries expanded outward. Shown here in the early 1960s, Fayetteville Street was no longer the retail shopping center of the city and as businesses departed they left behind abandoned buildings. In an effort to revitalize downtown Raleigh, city officials began discussing the idea of creating a downtown pedestrian mall that might encourage redevelopment of the city's core. The mall project was widely debated. Some saw it as an opportunity while others were mournful about the loss of Raleigh's preeminent main street. (Courtesy Office of Archives and History, Raleigh.)

On January 1, 1976, Fayetteville Street was permanently closed to vehicular traffic and construction on the new pedestrian mall began. For more than a year, construction crews tore up the former road surface and replaced it with terraced plazas, paving stones, flower beds, and fountains. The first three blocks of the new mall were dedicated in November 1977 and reopened to pedestrian traffic. This perspective, taken from the State Capitol, shows the new mall shortly after its opening, with the Raleigh Convention Center at its southern end. Although the 1980s saw the return of some merchants to the area, Fayetteville Street Mall did not regain the vigor of its past. In recent years, the desire to see downtown Raleigh thrive again has led to plans to restore Fayetteville Street as a thoroughfare. (Courtesy Office of Archives and History, Raleigh.)

Although many retailers had left downtown by the 1970s, the district continued to employ thousands of workers in state government and professional services. Lunchtime was a particularly heavy time for walkers along the mall and lunch-oriented fast food establishments prospered. This popular hot dog vendor, seen here in 1973, was a common sight to downtown. (Courtesy Raleigh City Museum.)

Entrepreneurs continue to rediscover downtown Raleigh, shown here in 2001. With new construction, including the First Union Capitol Center in 1991, and renovation of existing commercial landmarks, modern office space became plentiful and energized downtown growth. These businesses in turn were benefited by the upsurge in traffic due to cultural institutions, festivals, and civic events. (Courtesy Raleigh City Museum.)

Viewed today, Raleigh is a city active in government, business, education, and culture. The population continues to increase, bringing new residents from around the world. As its capital, Raleigh is an important city for the entire state of North Carolina. It is a true city of the 21st century, and one with an international reputation. Meticulously planned by state commissioners in the 18th century, Raleigh was designed as a city that would grow and develop

into a strong seat for state government. Their design is still evident in downtown Raleigh, although the city itself has grown to encompass much more than the 1,000 acres originally allotted. Raleigh's development has been the result of many individuals, events, and innovations. Now in its third century, Raleigh's revitalized downtown is composed of a curious mixture of the past and present. (Courtesy of Raleigh City Museum.)

INDEX

Agriculture Building, 18, 112, 114
Alderson, Thomas Barton, 38
Alfred Williams and Company, 43
Ambassador Theatre, 59
American Legion Parade, 111
Angus Barn, 119
BTI Center for the Performing Arts, 117
Baptist Female University, see Meredith College
Baptist University for Women, see Meredith College
Basie, Count, 65
Bloodworth Street, 55
Bloomsbury Park, 77
Blount Street, 25, 54, 75, 87, 90
Blue Ridge Road, 37, 102–103
Borden Building, 115
Boylan-Pearce Department Store, 43, 49, 93
Braxton's Music, 47
Brewer, Fisk P., 81
Briggs, Thomas H., 26, 74
Briggs Hardware Building, 6, 8, 26, 49, 115
Brimley, H.H., 114
Brown, Henry J., 24
Brown-Wynne Funeral Home, 24
Bryan, R.A., 94
Bryan, William Jennings, 19
Burke Square, 36, 78
Burrage Music Company, 47
Busbee, Lula, 8, 80
CP&L, 57, 77
Cabarrus Street, 54, 59
California Restaurant, 61
Cameron, Duncan, 83
Cameron Park, 70, 73, 95
Cameron Village, 8, 72, 94, 95
Campbell, William, 81

Canova Statue, 14
Capital Boulevard, 69
Capitol Broadcasting Company, Inc., 67
Capitol Theatre, 60
Carolinian, The, 52, 53
Casso's Inn, 12, 115
Central Prison, 33, 34–35
Century Post Office, 4, 32, 42, 48, 57
Chatham County, NC, 104
Christ Church, 4
Christmas, William, 2
Christmas Parade, 107, 108
Citizens National Bank, 6, 42, 45
City Hall, 32, 64, 91
City Market, 120
Civil Rights Movement, 8, 89, 96, 97, 98-99
Civil War, 15, 18, 30, 39, 48, 79, 102–103, 111
Clay, Henry 90
Coleman, Clarence C., 118
Colonial Stores, 95
Commercial National Bank, 45
Confederate Soldiers Home, 39
Confederate Veterans Parade, 111
Cross and Linehan Clothing Company, 61
Cumbo's Barber Shop, 55
Daniels, Josephus, 29, 59, 76
Davie Street, 30, 48, 61, 64, 88, 102–103
Delany family, 85
Denmark Photograph, 111
Denson, Kate, 91
Devereux Meadow Baseball Park, 7, 69
Dillon Supply Company, 47
Dix, Dorothea, 36
Dodd, James, 26

Dodd, William H., 74
Dodd-Hinsdale House, 74
Dombalis, Nicholas John, 60
Dorothea Dix Hospital, 36
Dorton, J.S., 105
Dorton Arena, 105
Douglas, Stephen A., 19
Duke-State football game, 68
Durham Life Insurance Company, 61, 66
Eagle Hotel, 18, 112
Earhart, Amelia, 71
Eckerd's, 49
Edenton Street, 18, 87, 112
Education Building, 112
Edwards and Broughton, 28
Ellington, Duke, 65
Eure, Thad Jr., 119
Exchange Plaza, 32
Executive Mansion, 4, 36, 74
Falls Lake, 118
Fayetteville Street, 4, 6, 7, 8, 11, 12, 15, 18, 20–21, 25, 28, 30, 32, 40, 41, 42, 43, 44, 48, 49, 50-51, 52, 56, 57, 58, 59, 61, 62, 64, 66, 70, 72, 81, 88, 101, 107, 108, 110, 111, 115, 116, 121, 122
Federal Building and Post Office, 82
First Union Capitol Center, 123
Fletcher, A.J., 67
Fletcher, Fred, 67
Fowle, Gov. Daniel G., 74
Fred Fletcher Park, 115
Freedmen's Bureau, 83
Gatling, Bart family, 76
Gibbons, Kaye, 119
Governor's Mansion, see Executive Mansion

Governor's Palace, 15, 18, 36, 74
Grand Theatre, 58
Great Blizzard of 1899, 40
Greater Raleigh Chamber of Commerce, 118
Greene, George R., 97
Hamlin, Capt. J.E., 118
Hamlin Drug Company, 118
Hanley, Fallon, 59
Hargett Street, 7, 15, 41, 52, 54, 55, 65, 80, 102–103, 118
Harrelson Hall, 86
Harris Barber College, 54
Harris, Samuel, 54
Hawkins, Dr. and Mrs. Alexander B., 75
Hawkins-Hartness House, 75
Hayes-Barton, 70, 76, 100
Haywood, Dr. Fabius, 11
Haywood, John, 10, 11
Haywood Hall, 10, 11
Haywood's Soda Shop, 55
Heck, Col. Jonathan M., 75
Heck-Andrews House, 75
Henry Clay Oak, 90
Henry G. DeBoy Grocery Store, 30
Hillsborough Street, 73, 74, 88, 102–103, 116
Hinsdale, John, 74
Hogg-Dortch Building, 12
Holladay Hall, 86
Holshouser, Gov. James E. Jr., 106
Holt, Joe, 96, 97
Holt, Joseph and Elwyna, 96, 97
Hotel Sir Walter, 20–21, 62, 63, 65, 66
Hudson-Belk Department Store, 44, 95
Hugh Morson High School, 8, 82, 109
Hunter, Isaac, 7
Hurricane Fran, 100
Hurricane Hazel, 100
Jervay, P.R., 53
Joel Lane House, 10
Johnson, Andrew, 12, 16, 19, 115

Johnson, John M., 118
Johnson, Lyndon B., 63
Jolly, Benjamin Rush, 26
Jolly's Jewelers, 26
Jones Street, 113
Kenton, Stan, 46
King, Martin Luther Jr., 97, 98–99
King's Business College, 88
Lake Howell, 77, 109
Lane, Joel, 2, 7
Lane Street, 113
Lassiter Mill, 17
Legislative Building, 15, 113
Lightner Arcade and Hotel, 52, 65
Lightner, Calvin E., 52
Lincoln Theatre, 59
Lovejoy, Jefferson Madison, 78
Lovejoy's Academy, 78
Mahler, Henry, 23
Market House, 32
Marling, Jacob, 9
Martin Street, 44, 47, 57, 60, 62, 72
McCurdy, I.A.D., 71
McDowell, T.B., 65
McDowell Street, 62, 81
Mecca Restaurant, 60
Memorial Auditorium, 4, 46, 64, 65, 116, 117
Meredith College, 87
Method, 79
Metropolitan Hall, see Market House
Minerva, 28
Mitchell, Samuel S., 97
Moore Square, 120
Mordecai Historic Park, 12, 16, 115
Morgan Street, 11, 12, 39, 72, 115
Municipal Building and Auditorium, 42, 45, 64
Murphey School, 81, 82
Murray, Elizabeth Reid, 116
NAACP, 89
Nash Square, 62
Needham Broughton High School, 82, 98–99
New Bern Avenue, 39

News and Observer, 29, 59
North Carolina Car Company, 22
North Carolina College of Agriculture and Mechanical Arts, see North Carolina State University
North Carolina Office of Archives and History, 113
North Carolina State Agricultural Society, 105
North Carolina State Board of Education, 112
North Carolina State Fair, 8, 39, 101, 102–103, 104, 105, 116
North Carolina State Museum of Natural Sciences, 18, 114
North Carolina State University, 64, 68, 86, 102 103
North Carolina State University Belltower, 4
North Carolina Symphony, 117
North Carolina Theatre, 117
North Street, 90
Nowell, Ted, 59
Oak View, 16
Oakwood, 73, 76
Oberlin, 73
O'Kelly, Berry, 79
O'Kelly School, 79
Olivia Raney Library, 88
Olson, Nancy and Jim, 119
Otey, Charles, 54
Park Hotel, 62
Peace, William, 83
Peace College, 83
Peace Street, 82
Peden Streel Company, 92
Person Street, 81
Pilot Cotton Mill, 31
Polk Street, 25
Pullen Building, 42, 48, 61, 66, 88
Pullen, Richard Stanhope, 77
Pullen Park, 4, 77, 109, 115
Quail Ridge Books, 119
Raleigh, Sir Walter, 2, 115

Raleigh Academy, 78
Raleigh and Gaston Railroad, 7, 22, 23
Raleigh Caps baseball team, 69
Raleigh Centennial Parade, 110
Raleigh Chamber of Industry, see Greater Raleigh Chamber of Commerce
Raleigh City Flag, 8, 90, 91
Raleigh, City of (government), 90, 91, 121
Raleigh City Museum, 6, 8, 115
Raleigh City Schools, 81, 97, 118
Raleigh Civic Center, 116, 122
Raleigh Cotton Mill, 30
Raleigh Female Institute, see Peace College
Raleigh Fire Department, 38
Raleigh High School, 68
Raleigh Junior Woman's Club, 63
Raleigh Kiwanis Club, 63
Raleigh Little Theatre, 116
Raleigh Merchants Bureau, 107, 108
Raleigh Municipal Airport, 71
Raleigh Municipal Building, 91
Raleigh Police Department, 38
Raleigh Street Railway, 7, 25
Raleigh Times, 28
Raleigh Waterworks, 7, 39
Raleigh-Durham Airport, 71
Raney, Richard Beverly, 88
Red Cross, 8, 92
Research Triangle Park, 119
Rex Hospital, 37, 87
Rex Hospital School of Nursing, 87
Riddick Stadium, 7, 68
Riddle, Hubert Eugene "Bubba" Jr., 56
Rogers, Will, 63
Roosevelt, Theodore, 19, 63, 110
Russell, Sally Blackwell, 57

S&W Cafeteria, 61
St. Augustine's College, 85
St. John's Hospital, 37
St. Mary's School for Girls, 83, 94
St. Mary's Street, 37, 82
Salisbury Street, 58, 80, 88, 112
Seaboard Air Lines (CSX), 23
Sears Roebuck, 94, 95
Second Empire Restaurant, 74
Shaw Hall, 84
Shaw University, 84
Smedes, Rev. Aldert, 83
South Street, 81
Spanish-American War, 8, 90
Stainback, Vivian Blackwell, 57
State Capitol (1840), 4, 9, 13, 14, 15, 42, 50-51, 73, 106, 110, 113, 115, 122
State Library of North Carolina, 113
State Museum of Natural History, see North Carolina State Museum of Natural Sciences
State Penitentiary, see Central Prison
State Theatre, 58
Statehouse (1794), 7, 9, 11, 13, 14, 107
Stephenson's Music Company, 46
Swain, E. Reginald, 53
Taft, William Howard, 19
Tan, Amy, 119
Taylor, Herman L., 97
Taylor, James G., 54
Taylor and Mitchell Law Firm, 97
Taylor's Billiards, 54
Three Presidents Monument, 106
Truman, Harry S, 63, 106
Tupper, Henry Martin, 84
USS Raleigh, 8, 90, 91
Union Bus Station, 72
Union Square, 13, 14, 50, 51, 106, 113
Union Station, 70
Valand, Leif, 94
von Trapp, Maria, 63
Vurnakes, Alex and Gus, 61
WPTF, 61, 66
WRAL, 46, 67
W.T. Grant and Company, 49
Wake County Courthouses, 45, 48, 88
Wake County School System, 81, 118
Wake Crossroads, 7
Wakefield, see Joel Lane House
Washington, George, 14
Washington Elementary School, 81
Williamson House, 76
Wilmington Street, 52
Wilson, Woodrow, 19
Winston, Charles, 119
Wolfe, W.O., 33
Woods and O'Kelly General Store, 79
Woolworth's lunch counter, 96
World War I, 92, 101
World War II, 8, 92, 93, 94
Wright Brothers, 71
Wyatt, Marshall, 59
Wyatt, Job P., 27
Wyatt-Quarles Seed Company, 27
Yarborough House, 18, 19, 20–21, 42, 44, 63
Yastrzemski, Carl, 69
Yates Mill, 17
York, J.W., 94